IMAGES
of America

IRISH AMERICAN
HERITAGE CENTER

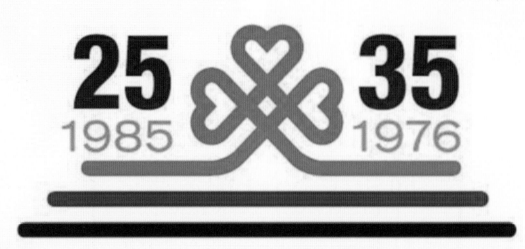

IRISH AMERICAN HERITAGE CENTER

A sign of the times, this logo celebrates the fact that 35 years ago a group of Irish Americans incorporated as the Irish American Heritage Center and, 25 years ago, purchased the building that became its home. (Courtesy of the IAHC.)

ON THE COVER: This scene was captured during the very first days of the cultural center's existence. Painter Owen McGuiness is painting the doors a welcoming green.

IMAGES
of America

IRISH AMERICAN HERITAGE CENTER

Monica Dougherty and Mary Beth Sammons

Carry on
the tradition,
Mary Beth.
Irish Blessings!
Monica

ARCADIA
PUBLISHING

Published by Arcadia Publishing
Charleston, South Carolina

Printed in the United States of America

Library of Congress Control Number: 2010943016

For all general information, please contact Arcadia Publishing:
Telephone 843-853-2070
Fax 843-853-0044
E-mail sales@arcadiapublishing.com
For customer service and orders:
Toll-Free 1-888-313-2665

Visit us on the Internet at www.arcadiapublishing.com

*To the men and women who made the dream for an Irish
cultural center and community gathering spot a reality*

CONTENTS

ACKNOWLEDGMENTS

We would like to acknowledge, first and foremost, the original visionaries whose dream has lived on and is ever growing, in particular, Hugh and Josie O'Hara and Mike and Kay Shevlin.

While there are far too many names to list here, some of those who were significant in shaping the story for this book include Gabe and Mary Keleghan, Tom and Mary McNamara, Tom and Breege Looney, Pat Burke, Ambrose Kelly, Mike Boyle, Peig Reid, John O'Malley, Robert Dyra, Eileen O'Connor, Mary O'Reilly, and Nora Murphy.

Thanks to present-day board president (and son of cofounders Tom and Mary McNamara) Bob McNamara and executive director Tim McDonnell for their contributions, support, and encouragement.

A special thanks goes to the volunteers and staff of the Irish American Heritage Center for sharing their memories, personal stories, and access to all the information and photographs. We also want to thank Kathy O'Neill, Brian Donovan, Noel Rice, Frank Crowley, Leslie Singel, and Mary Griffin for their generosity in sharing information. A special thanks goes to archivist Tom Boyle for his commitment to preserving history and for sharing his amazing memory.

A big thanks is due to our editor, Melissa Basilone, for all her help and encouragement.

Finally, it is truly outside the scope of this book and an impossible task to thank each of the wonderful volunteers who over the years have poured their hearts and souls into creating and maintaining this legacy to the Irish heritage and culture.

Note that for many of the parade and fest photographs it is also an impossible task to identify each and every person. We hope our readers enjoy taking this journey through the history of the Irish American Heritage Center. Perhaps you'll recognize a few faces—maybe your own!

Unless otherwise noted, all photographs are courtesy of the Irish American Heritage Center photographers John O'Malley and Thomas Boyle.

FOREWORD

Since its beginning in 1985, the Irish American Heritage Center has provided a home for the Irish community for 25 years—the culmination of a dream that originally started in 1976.

In a city where a quarter of a million people claim Irish ancestry, the Irish have played a pivotal role in the history of Chicago. The Irish American Heritage Center (IAHC) is the home for this community and the place where the history and the cultural traditions are kept alive.

More than preserving its past, the Center maintains and enhances the culture by hosting lessons in Irish music, dance, and language along with programs and events that feature the best in Irish music, literature, theatre, and dance from Chicago, the United States, Ireland, and the world over.

We hope that through the pictures and stories collected here, readers can relive this extraordinary story and get a sense of the tremendous pride of those who built it. In its own way, the book is a tribute to the founders and all of the countless others who dedicated their time and efforts to realizing the dream.

I was just a boy in 1976 when the IAHC was founded. My parents and aunts and uncles were part of the original founding membership. I grew up with the Center and now have the privilege of serving as the president of its board of directors. While my journey with the IAHC is a personal one, so is the story of the Center itself. It has been a personal journey of thousands of volunteers, for over 35 years, to build a home for a community—a home for themselves and the generations to follow. I hope you enjoy our story as much as we have enjoyed living it.

—Robert McNamara
President, Board of Directors
The Irish American Heritage Center

INTRODUCTION

Early Irish immigrants played a pivotal role in the immigrant history of Chicago, forming a visible Irish community from the start. Building Fort Dearborn in 1803, Capt. John Whistler was among the first of the Irish who came to the city. They soon became an indispensable part of American life and integral to the story of growing Chicago. Since the city's infancy, the immigrant struggles and triumphs of the Irish have been rooted in the Midwestern urban center's history.

In the same way the green dye colors the Chicago River every St. Patrick's Day, these new Irish arrivals—many tradesman, laborers, clergy, politicians, municipal workers, police, and fire fighters—made their mark on Chicago and wove their rich and colorful history into the fabric of the city. They created a legacy of unforgettable moments, helping to build Chicago's infrastructure, including the Illinois and Michigan Canals, along with the city's schools, churches, hospitals, and businesses.

As the city of Chicago grew from a small town into a bustling metropolis, the Irish in Chicago grew with it. They came together through their devotion to Ireland and their desire to make a home for themselves. The first official club of the Irish in Chicago was formed in 1901, when a group of Irish Americans, all denizens of the famous Vogelsong restaurant, formed the Red Branch Knights (named for an heroic band of ancient Celtic warriors) to help promote a more responsible image of Irish in Chicago. The group soon changed its name to the Irish Fellowship Club and was one of the key supporters of the founding of the Irish American Heritage Center (IAHC) more than 70 years later.

The other force that united the Chicago Irish was their high level of involvement in local politics. In the 1930s and 1940s, Irish American politicians were poised to launch an era of big-city Irish mayors. Of Chicago's 45 mayors in the first 100 years, 3 had been Irish American. Over the next half century, four of the five mayors who held office would be of Irish descent, including Richard M. Daley and his father, Richard J. Daley.

As the Irish became entrenched in Chicago, the vitality of Irish culture became synonymous with the city. Some of the more recent examples keeping the artistic legend alive include Michael Flatley, the traditional Irish dancer and choreographer, who has held the leading roles in the widely acclaimed *Riverdance* and *Lord of the Dance*, and actor George Wendt, who was raised in the Beverly neighborhood in the 1950s and 1960, and is best known to Chicagoans and the rest of us as Norm on *Cheers*.

Other legendary Irish Chicagoans include "Honest John" Comiskey, father of White Sox owner Charles Comiskey; Mayors John Hopkins (1893–1895), Edward F. Dunne (1905–1907), Edward J. Kelly (1933–1947), and Martin J. Kennelly (1947–1955); authors James Farrell (*Studs Lonigan*) and Mary Pat Kelly (*Galway Bay*); newspaperman Finley Peter Dunne; and musicians John Williams and Liz Carroll, among many more.

As the Irish community became more and more dispersed, a group that wanted to claim their Irish ancestry formed the Shamrock American Club in 1939. This club would later be a gathering point for a small group of dedicated Chicagoans who longed to find a home to preserve and carry on the legacy of their Irish culture and to reclaim the sense of belonging to their communal Irishness. The IAHC was incorporated in Illinois in 1976, and the group started taking steps to find a permanent facility.

According to the 2006 census, about 36.3 million Americans claim Irish ancestry, and triple that number—96.3 million—celebrate St. Patrick's Day in March. No question, there is a demand for Irish Americans to carry their culture with them. The Irish in Chicago were determined to do exactly that.

In 1985, the IAHC founders purchased the Mayfair School, located on the northwest side of Chicago, from the Chicago Board of Education. It was an abandoned, graffiti-filled school building. A passionate and ambitious volunteer crew of tradesmen and craftsmen transformed it into the IAHC. Initial funding and support for the "Center" came from hundreds of donations, both large and small, from individuals throughout the Irish community along with significant support from the Shamrock American Club and the Irish Fellowship Club. The building was purchased for $500,000, the title was transferred, zoning granted, the demolition began, and construction of the dream—a home for the Irish of Chicago—began.

This book brings to life that courageous vision and shines the spotlight on the people who come today to this massive 86,000-square-foot building, which houses an authentic Irish pub, a 650-foot theater, a ballroom, library, museum, and classes for language, dancing, and music. It is a magnificent story with a rich cast of ordinary people who have been extraordinarily passionate in their efforts to create a home for the Irish in Chicago.

The Center's founders kept the longing for and the legacy of their homeland alive and created a community home for others to share their love of Ireland and the culture, traditions, and creative talents of the Irish. Beyond that, they also asked the following questions: How can I share the gifts of my heritage? How can I pass them down to future generations? How can I help make a difference?

With a grit and gusto that defied the turbulent past and the tragedies of the Irish people, that is exactly what they did. Today, the community of the IAHC gives life to their triumphant spirits.

Just like the story of Irish in Chicago, the IAHC's history is intricately woven into the story of Chicago and many of its landmarks: The Center's boiler was purchased from the University of Illinois, the pub's wooden floor was transported from Piper's Alley (home of Second City), and two of the major display cases were donated by the Field Museum of Chicago.

The book also chronicles a number of influential people from all walks of life who have helped celebrate at the many ground-breaking events, including a number of dignitaries from Ireland, politicians from the City of Chicago, celebrated authors, entertainers, filmmakers, and historians.

Thanks to the hundreds of passionate volunteers, a professional staff, and a dedicated 16-member board of directors, the IAHC continues today to deliver upon its mission as a nonprofit organization, enhancing the quality of life of its members and those in the surrounding community. The IAHC is now a premier institution where through dance, language, music, and festivals, Irish heritage is celebrated and passed on to future generations.

If not for the vision of the original founders and all of the volunteers over the years, the IAHC would not exist. The mission of this book is to celebrate the story of the IAHC and the hundreds of ordinary people who went to extraordinary lengths to bring it to life.

We have tried to tell the powerful story through the words, photographs, and memorable moments of the founders, volunteers, and the many visitors who come through its doors each year. Our hope is that the book chronicles and pays homage to that legacy and that it continues to share the story as it is passed down to future generations.

The time for this book is now, as the Center celebrates the 35th anniversary of its founding and its 25th anniversary in its physical setting.

One

A Circle of Friends Unites

Beneath the tricolor green, white, and orange flag of Ireland, the stars and stripes, and the flag of the City of Chicago, a trio of kelly-green doorways welcomes visitors to the IAHC in Chicago. Inside the doors, "a hundred thousand welcomes" awaits those who share an Irish heritage and others yearning for a touch of Irishness.

They come to the IAHC to celebrate the rich history, legacy, culture, and rituals that define a people whose resilience, perseverance, hard work, and contagious charm speak volumes about the triumph of the human spirit.

As the Center celebrates the 35th anniversary of a dream fulfilled and the 25th anniversary of its physical home, a turn-of-the-century building that spans the whole block of Knox Avenue on Chicago's northwest side, it is important to reach back to its true beginnings and the elaborate family tree of ancestors of the founding fathers—Irish families whose every branch dangles with thousands of stories, perhaps millions of them.

War heroes, adventurers, farmers, tradesman, and more, they crossed the Atlantic in droves, especially in the years of the Great Starvation in Ireland between 1845 and 1852. The subsequent emigration almost wiped out a communal culture, a language, and a way of life. Their faith may have been shaken, but the Irish immigrants kept their heads held high and there developed in the Irish American people a fierce desire to preserve what was so dear and almost lost forever.

Chicago became a home for many of these fiercely determined quintessentially Irish lads and lasses. They wanted to pass on their history, the story of who they were and where they had come from, to future generations.

The IAHC was born out of those dreams and the passion of the late Hugh and Josie O'Hara, who envisioned an Irish library and a cultural center in the Chicago area. It was a dream, shared by the Shamrock American Club, for a permanent home for their meetings and special events. "It is hard to believe there is no home for the Irish in Chicago," Hugh O'Hara was known to say. "We'll change all this."

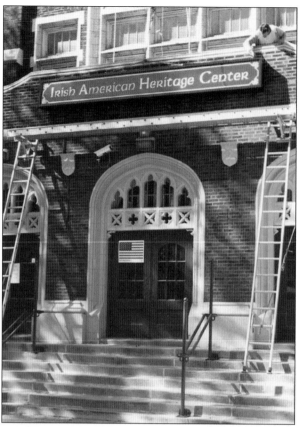

In 1975, a small circle of Irish immigrants and first-generation descendants came together to connect and create a home for the Irish in Chicago, a city that boasts 12 Irish mayors and epitomizes the essence of Irishness. Many met through the Shamrock American Club, the Irish Fellowship Club, and other clubs throughout the city.

"Our dream was to build a home for the Irish in Chicago," says Mary McNamara, pictured here with husband Tom. Mary and Tom were among the founding members, and Mary was an Irish dance instructor for more than 35 years. "The hope is that all of our children, grandchildren, and future generations will find the inspiration and community here to carry on what it means to be Irish and a community in America."

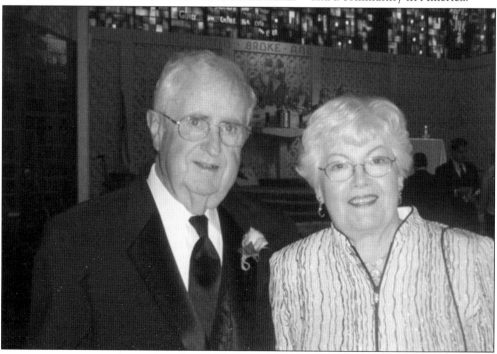

"The driving force behind the dream for Chicago's Irish to have a building of their own was Hughie O'Hara," says Mrs. McNamara. Hugh O'Hara (1907–1985) was born on the island of Aranmore, Ireland, off the coast of Donegal, and came to America as a young man. After 60 years, the major dream of his life came true in the purchase of the building that became the IAHC.

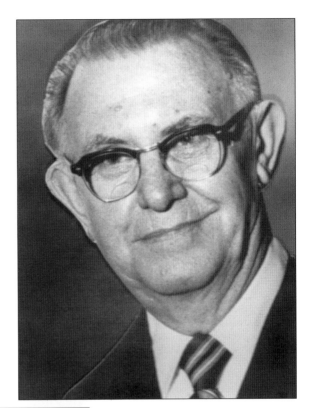

Born Anna Josephine, Josie O'Hara (1916–1980) was a good match for her future husband, Hugh, as she was fanatical about the Irish and about the Irish organizations to which she belonged. She became just as fanatical about supporting Hugh and those who worked with him in achieving the fruition of his lifelong dream of seeing an Irish center in Chicago.

Pat Roche's Harp and Shamrock Orchestra played at the Irish Village at the Chicago Century of Progress from 1933 to 1934. Pat was also an accomplished step dancer who lived to be close to 100 years of age. His legacy lives on in his children and grandchildren, who continue to visit the IAHC today.

Dancing was also passed down through the generations and appreciated by all the early immigrants to the city. Here, a group of Irish lasses gets ready to perform at a function.

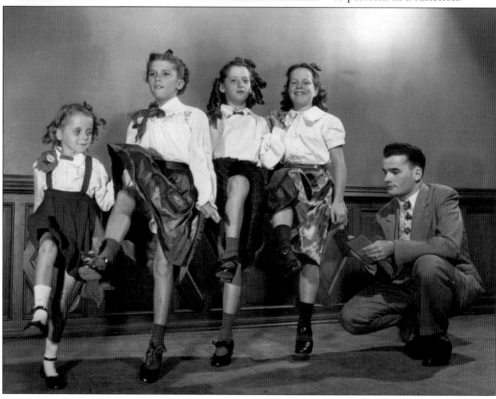

The Ceoltoiri Maghlocha is seen here performing at an early Taste of Ireland event. These were held at various venues throughout the city to raise funds for the purchase of a permanent site.

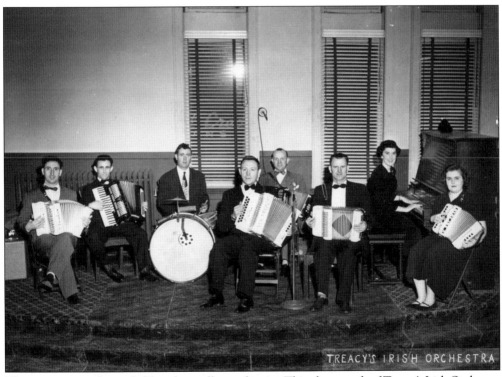

There were many dances held at places all over the city. This photograph of Treacy's Irish Orchestra was taken at McEnery Hall at Madison and Pulaski in 1951. From left to right are Terry "Cuz" Teahan, John Cook, Pat Richardson, Tom Treacy, Tim Guiheen, Tom Kerrigan, Maisie Griffin (Mitchell), and Virginia Sheehan. (Courtesy H. Gershan.)

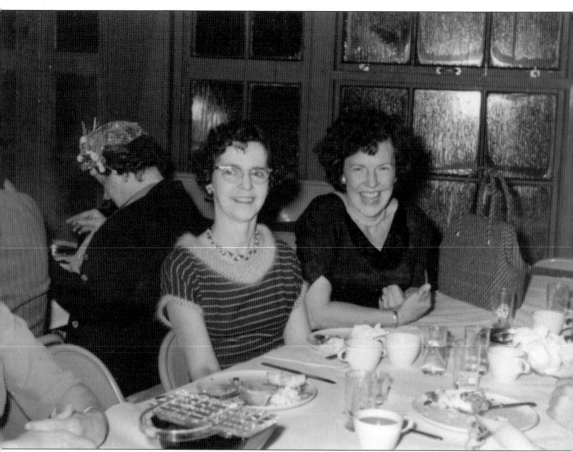

Full of boundless energy and a driving force in the early group of Irish immigrants was Eileen "County Wexford" O'Connor. Here Eileen (right) and her sister Margaret attend a celebration dinner. Eileen was the recording secretary for the Shamrock American Club.

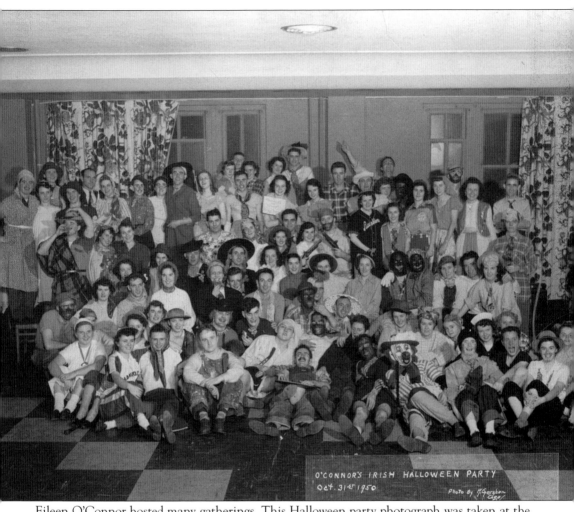

O'CONNOR'S IRISH HALLOWEEN PARTY
Oct. 31st 1950
Photo By J. Gershon Chgo.

Eileen O'Connor hosted many gatherings. This Halloween party photograph was taken at the Keymans Club, also at Pulaski Road and Madison Street on the West Side of Chicago. The Keymans Club was another favorite gathering place.

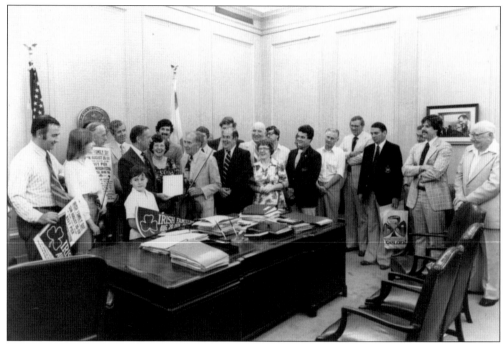

The first of what would become an annual fundraiser for the IAHC was held in August 1977 at the International Amphitheater at Navy Pier. The event, called Irish Family Day, was founded by Tommy Ryan and raised $10,000, which was funneled into the Irish American Heritage Center Building Fund. Irish Family Days were held through 1983 at Navy Pier and then at Hawthorne Park. In 1978, the Shamrock American Club added $50,000 to the coffers. In this photograph, Eileen O'Connor, Tom Ryan, Mike Shevlin, and Maureen O'Looney receive the permit for Irish Family Day from Mayor Michael Bilandic.

In 1985, the early visionaries found the block-long Mayfair Junior College property. Driven by O'Hara fundraisers, the group had earned $500,000 to buy the abandoned building on the corner of Wilson Street and Knox Avenue.

The Shevlin brothers remember the weekly Wednesday-night bingo events run by their father, Mike, and Nick Feller. Every Tuesday night, the rich aroma of soda bread filled their Arlington Heights home as their mother, Kay, baked up loaves of bread for the bingo fundraisers. "Our cousins and us [sic] had to wear these bright green 'Shevlin Clan' shirts with the name ironed on," Tim Shevlin recalls.

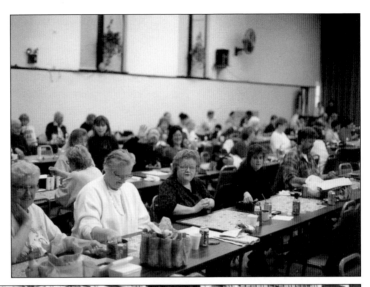

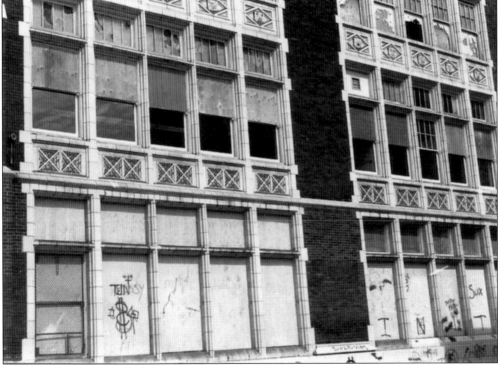

"When we first saw the building, we were all, like, oh my God. The paint was peeling, the windows smashed out, and it took a lot of imagination to see what could be," says Mary McNamara, who has taught Irish dancers for more than 35 years and whose seven children and now 20 grandchildren call the Center home. Her youngest son, Bob, is the present-day president. What the building had going for it was its location in the city proper and also along Chicago Transit Authority (CTA) lines, as well as being near the Kennedy Expressway on the northwest side of the city. "They called it East of Eden," recalls Tim Shevlin. According to founding member and future president Tom Looney, another thing it had going for it was that it was purchased at a bit of a discount due to its ramshackle condition.

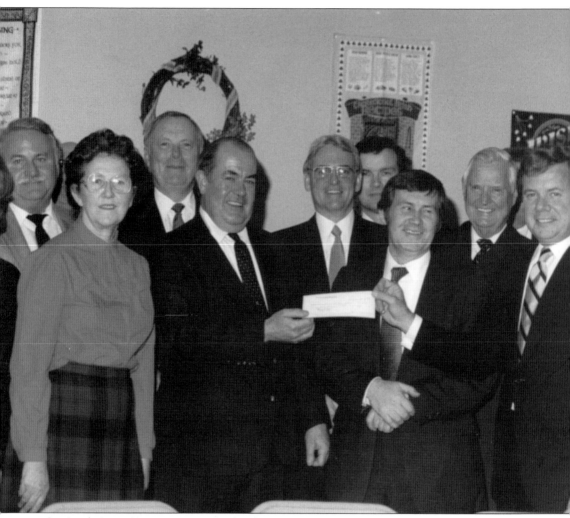

On April 18, 1985, Mary McNamara's brother Mike Shevlin, the first president of the IAHC, signed the deed to the building, which was notarized by founding member Breege (Bridget) Looney. The Irish Fellowship Club of Chicago boosted the possibilities by donating $100,000, to be contributed in $25,000 payments over the course of four years for a building renovation fund. Receiving the first installment from Tom Tully, president director of the Irish Fellowship Club, are, from left to right in the foreground, Mary O'Reilly, Mike Shevlin, and Tom Looney. In the background are Irish Fellowship Club members, including Edward Burke between Shevlin and Looney.

A group of tradesmen, spearheaded by Ambrose Kelly and Tom Looney, rallied their peers and rolled up their sleeves to transform the dilapidated building into the bustling Center it is today (read more about their efforts in chapter three). Over time, this group of passionate and ambitious volunteer tradesmen, plumbers, electricians, tuck pointers, and craftsmen transformed the ravaged building into the IAHC, a building filled from basement to rafters with all things Irish.

"Little by little, room by room, the building came to life," remembers Mary McNamara. It is through the blood, sweat, and tears of this committed corps of volunteer tradesmen that the Center's family tree took root for all Chicago Irish. The loyal team of workers has continued this work for 25 years, showing up every Saturday morning to renovate and upgrade the building.

"Everyone will always be welcome at 'the home' for Chicago land's Irish," says Thomas J. Boyle, former board president (1990–1993), who is the present-day museum curator and archivist and a contributing columnist for the *Irish American News.*

Today, the Center boasts 2,140 members, and more than 50,000 visitors walk through its doors every year. Says president Bob McNamara, "35 years ago our relatives were passionate about creating a home for the Irish in Chicago to celebrate our legacy and to pass on our culture to future generations. Now it is time to take our rightful place as the significant and premiere home where the Irish culture will be handed down to generations to come." Pictured here are, from left to right, Bob McNamara, Bob's uncle Mike Shevlin, Nora Murphy, Joe McDonagh, and Tom Boyle.

Two

PROFILES IN COURAGE

When Hugh O'Hara completed an arduous journey from his thatched-hut home in Aranmore in County Donegal to Chicago in 1924, he wanted to create a central point where Irish immigrants could meet, form a community, and support each other. A deeply religious young man, he came to Chicago knowing only the rigors of hard work on a barren island and the meager living his family had etched out as fishermen. He had one major goal: to devote his life to making sure there was a home for the Irish in Chicago. Whatever way it was to be accomplished, he wanted to create a lasting focal point for the Gaels who had landed in Chicago, a mecca for Irish immigrants.

Life in Chicago was not always easy for the man, who was described by friends as a joyous leprechaun, as he struggled to support his wife and four daughters. After 60 years of passionate dreaming, the man who would be dubbed the godfather of the IAHC saw his dream come true when the building was purchased in 1985. Sadly, he died shortly afterward.

Indeed, a groundswell of "yearning to pass on the culture" was bubbling, says president Bob McNamara. The dream became contagious. The O'Haras found kindred souls in the likes of Kay and Mike Shevlin, Mary (Mike Shevlin's sister) and Tom McNamara, the youngest Shevlin sibling, Peggy, and her husband, Don Launius. The O'Haras rallied Peig Reid, her husband, Michael "Joe" Reid, and dozens of other first- and second-generation Irishmen, including the Keleghans, Looneys, Kellys, Morans, O'Malleys, Burkes, and others in Chicago to make their dream a reality.

The story that started with the founding members speaks volumes about that resilience and fortitude. Thanks to them, the Center has been created to celebrate that heritage and defines that culture for future generations.

Mary (O'Looney) O'Reilly was born in 1922 in Ennistymon, County Clare. Mary's love of culture went back to her home in Ireland, where her mother had a trained mezzo-soprano voice, and Mary and her 11 siblings were introduced to music. As the chair of the IAHC Committee, she initiated and developed the Irish American Singers (still in existence today), the drama club (initially called the Irish Heritage Players and now known as the Shapeshifters), the Irish Heritage Lectures, the Forum, the arts gallery, and the museum. Mary's greatest accomplishment was the legacy of the 650-seat auditorium. She touched the lives of many at the Center and will be well remembered. After her death in September of 2010, it was revealed that it was she who had anonymously donated the carpeting in the library and museum.

Some of the past board members pictured here are, from left to right, John O'Malley, Tom McNamara, Tom Boyle, John McGrath (current president of the Shamrock American Club), Chuck Kinney, Gabe Keleghan, and Pat McKenna. Some of them are also peppered throughout the book with sleeves rolled up, ready and willing to do what is needed when it is needed. That is the true legacy and spirit of the founders.

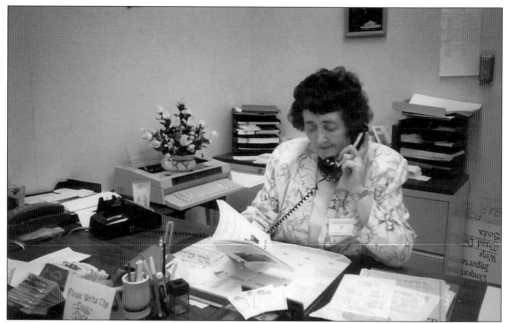

Born in County Mayo, Mary Griffin (pictured) has been a welcoming and familiar face in the IAHC office since its very beginnings. Mary's daughter Eileen remembers volunteering at the Center herself, starting in the kitchen. Eileen is still active and on many of the committees, doing the planning and hard work of making sure the fests and celebrations all happen.

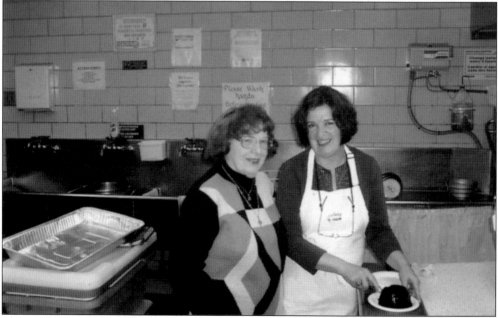

Maureen O'Looney's pride is obvious as she shares the spotlight here in the Center's kitchen with a Galway baker. Maureen, also from County Mayo, is another major driving force at the Center. Active in countless organizations and causes, including activities at Gaelic Park on the South Side, Maureen is also the proprietor of Shamrock Imports on Laramie Avenue near Belmont Avenue.

26

Mike and Kay Shevlin helped the O'Haras lead the troops. As they stepped forward toward their dream, they also had a grand time their son Mike Shevlin recalls. Mike Sr., brother-in-law Tom McNamara, and brother-in-law Don Launius were all members of the Shannon Rovers Pipe Band Color Guard, marching in all the parades and fests.

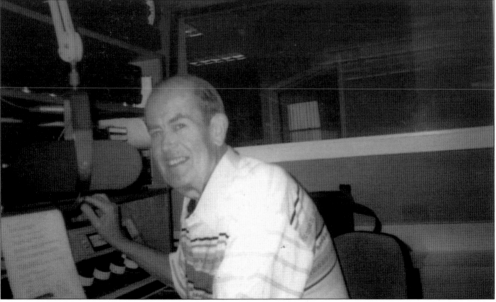

He may not have spoken with an Irish brogue, but Michael Shevlin was a leading figure in the Chicago area's Irish American community. "He would lead the parade, right in front of Mayor Daley," his son Mike recalls. Shevlin also hosted a radio show on Irish culture for 18 years, often bringing sons Tim and Mike to the Oak Park Arms where the show was broadcast.

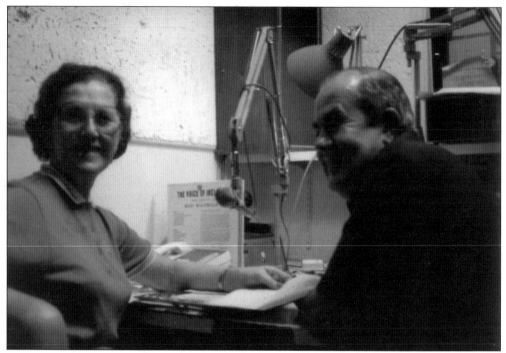

Mary O'Reilly, always ready to talk about the IAHC, had a chance to visit Mike Shevlin in his studio.

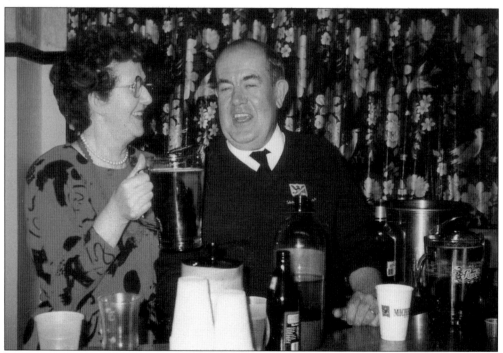

By 1977 and over the course of the next decade, the O'Haras and their team were busy raising money for a building to celebrate Irish books, music, arts, and all things cultural. Here, Mary O'Reilly and Mike Shevlin celebrate at one of these fundraising parties.

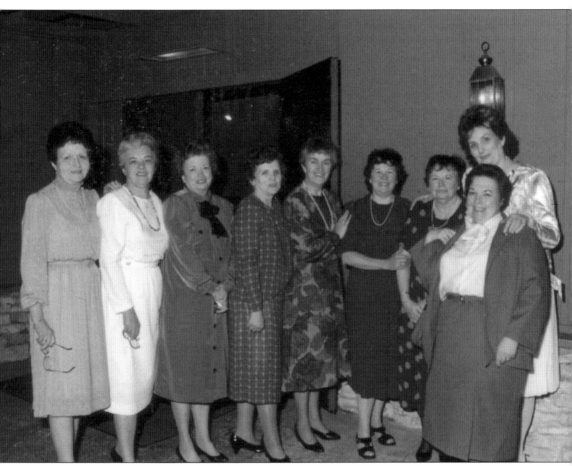

"It was a ragtag group of friends, some who had small dreams of a place to gather, and others like our dad, who dreamed of this behemoth center of culture for the Irish," says Tim Shevlin. The early group also included Kay Shevlin's circle of high school friends. They are, from left to right, Eileen (Sharkey) Doyle, Bridie (Hoban) Meyers, Mary (Tully) Halvorsen, Nora (Cunnea) Murphy, Mary (Flaherty) Lundin, Marie (Sullivan) Feller, Kay (O'Brien) Shevlin, Marge (Reynolds) Fric, and Mary (Cushing) Lundin.

Tom Looney, one of the founding members and a former IAHC board president (1993–1994), hails from County Clare and is the owner, with wife Breege, of the Abbey Pub on North Elston Avenue. Tom was very involved in scouting the current site, evaluating other prospects, and getting the final bid. Like many of the early enthusiasts and supporters, Tom continues to be actively engaged and is again serving on the board.

Three

BUILDING THE FUTURE

"We came in the door feet first," is how Ambrose Kelly describes the April day in 1985 when he and his crew of more than 60 carpenters, plumbers, electricians, painters, plasterers, and tradesman marched in the doors of the dilapidated three-story building that was to be the Center.

That was 25 years ago. The crew, some now in their 80s, was a devoted troop whose determination resembles the Keystone Cops, with a twist of Mother Theresa–like commitment to serve others thrown in. They arrive after a hard day at their own jobs and tool away into the late evening hours and all day long on Saturdays, when they arrive at the break of dawn. They break for tea at 9:00 a.m. and work through to lunch, a culinary feast usually prepared by an equally dedicated staff of women volunteers, at 12:30 p.m. "We took our coats off and kept our tool bags on and set to work," says Kelly, who came to Chicago from Ireland in 1957 and since then has traveled back and forth 47 times to visit family in County Mayo. "We've built or rebuilt this place on nickels, dimes, and a lot of sweat." Kelly took charge of the construction along with his good friend Tom Looney. "We never kept track of all the man hours that went into renovating, but we had at least 350 to 400 volunteers, sometimes 80 workers in one day," says Kelly.

The place was a mess, and "90 percent of the building's windows were broken and boarded up," Kelly recalls. "We brought in four-by-eight sheets of glass on trucks, laser cut all of them, and replaced all those windows, one by one." Aside from the graffiti, flimsy construction, poor electricity, and leaky pipes, Kelly says there was a bright spot, "The building had a good roof."

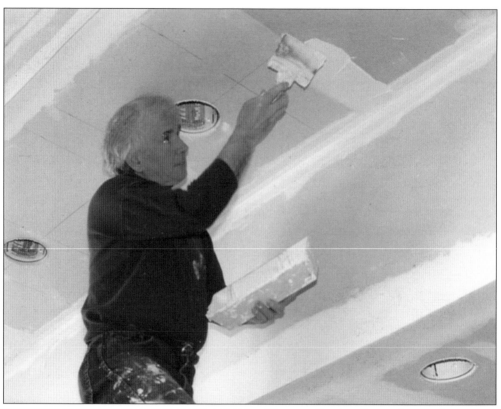

The very first hurdle was "to get the gangs out of the building," remembers Kevin Moran. "I remember we had our very first meeting, which was supposed to be about how we were going to get the gangs out, and we see a guy jump out of a third-floor window." Moran's handiwork can be seen throughout the building but specifically in the impressive fireplace in the Fifth Province.

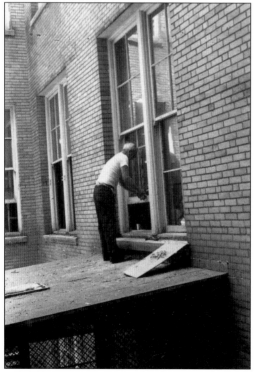

After clearing the building of gangs, the next step was boarding up all the broken windows and beginning the task of replacing each and every one.

One of the first projects on the checklist was the installation of an elevator. This proved to be a lifeline to the entertainment that took place at the Center from day one and throughout construction. Despite the dilapidated condition of the building, the Francis O'Neill Club met every Friday night for céilí dancing. The first theater production, *The Devil Came from Dublin*, was staged in 1986. Frank Neylon, one of the men who made sure the elevator worked, is pictured here.

In 1986, construction on the first floor and auditorium were underway. Mary O'Reilly spearheaded a sponsorship drive for theater seats, with 603 names marking the lives of IAHC supporters on them. Here, longtime volunteers Paul Heneghan (left) and Brian Donovan install some of the seats. A grand opening for the auditorium was held in 1989 with a concert by Frank Patterson, Ireland's celebrated tenor.

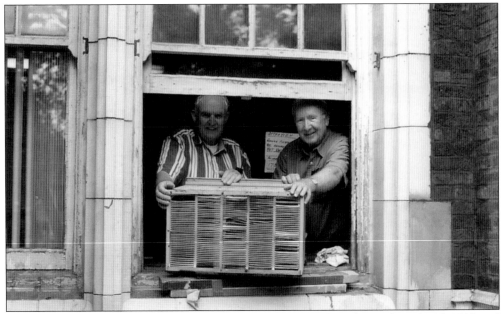

"We worked around the clock," says John O'Malley, former board president (1985–1987 and 1994–1995), construction team member, and IAHC photographer. "There's never been any pay, and there's never been anything called overtime. The first year we spent all our time patching water leaks so we could get the water back on and fixing broken windows." Joe Reid (left) and O'Malley install a much-appreciated air-conditioner.

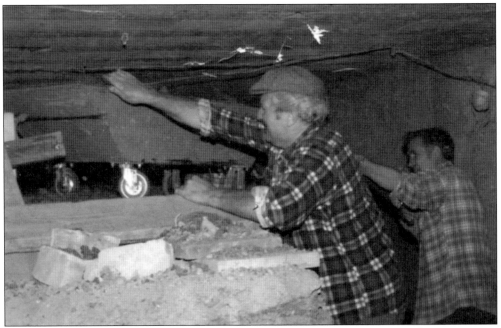

The crews remember a day when temperatures dipped to 14 degrees below zero. They were trying to hoist a compressor on a truck and get it into the building. They worked like coal miners, digging a 25-foot-long, 4-foot-wide tunnel under what is now the Fifth Province in order to get the heater into the building.

A great sense of personal pride can be felt in every nook and cranny of the building says O'Malley. This comes to life especially in the artwork of Ed Cox, former elementary school art teacher, who came to a few events at the Center and got hooked. Before long, he was a regular volunteer. Using the *Book of Kells* as his inspiration, his watercolors grace the hallways and converted classrooms. Here, Ed continues his work on a semicircle in the lobby.

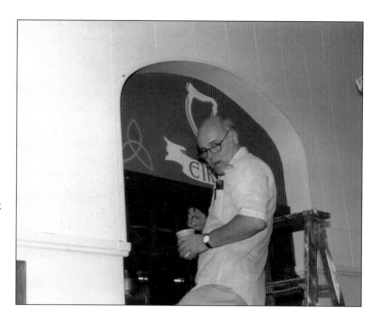

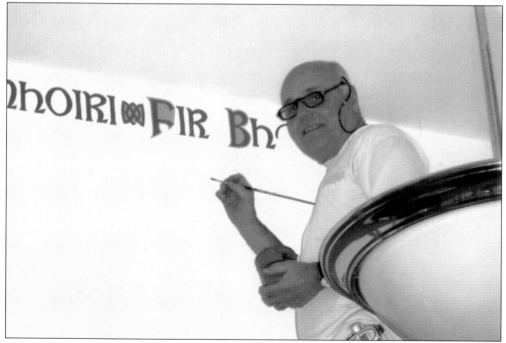

Ed's signature mastery is the literary border that he designed and painted that wraps around the ceiling of the library. It includes the names of well-known Irish and American literature icons, including F. Scott Fitzgerald, Sean O'Casey, Flannery O'Connor, Joyce Carol Oates, William Faulkner, and Jack London, among many others.

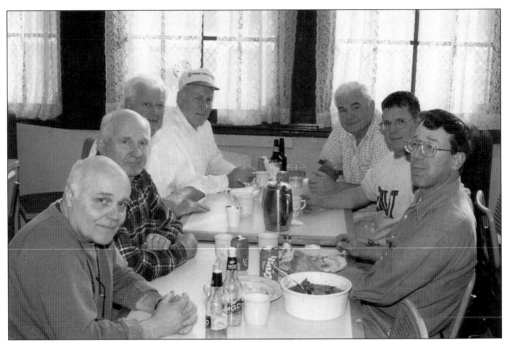

Even today, 25 years later, lunch for the construction crew on Saturdays is an impressive culinary production. Banquet tables loaded with mashed potatoes and, as Ambrose Kelly says, "Some warm and hardy meat," soda bread, more tea, and a smorgasbord of homemade bakery goods serve from 20 to 60 very hungry people. Seated around the table are, clockwise from the left, Ed Cox, Harry Barrett, Mike Kilcoyne, Pat White, Bill Casey, Mike Neary, and Tom Wolos.

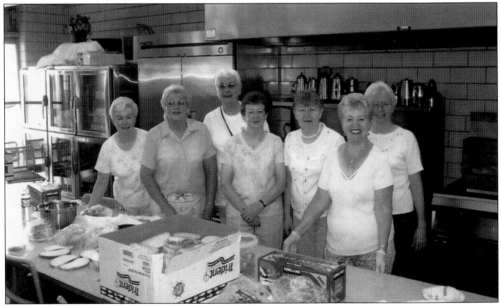

Over the years, a group of dedicated women and men have worked in the kitchen preparing the Saturday lunch. They also prepare the food for the many fests and celebrations. Getting lunch ready are, from left to right, Mary Keleghan, Mary Archbold, Pat O'Connor, Keleghan's sister-in-law Marion, Katie Byrne, Barbara Glynn, and Mary Ryan.

This group of hungry workers enjoying lunch and great company include, clockwise from the left, Frank Duffy, Phil O'Connor, Albert Ronan, Brian Donovan, Paul Heneghan, Bill McDonagh, Ed Cox, Pat Burke, and Patsy O'Donnell.

Brian Donovan, the IAHC genealogist, is usually found either in the museum or in the library on the last Sunday of each month for the genealogy sessions. Here, like everyone else, he pitches in helping to renovate one of the classrooms.

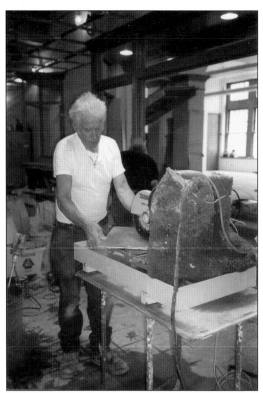

Ambrose Kelly, a man of many talents, is shown here cutting floor tiles.

Founding member and former board president Gabe Keleghan can still be found helping out.

"Like father, like son" seems to be a theme around the IAHC. Gabe's son Joesph Gabriel Keleghan is hard at work on the plumbing.

Mike Cleary works on the ducts. The renovation work is never complete.

Colman Travers measures twice to cut once. The reward for the dedicated workers is the camaraderie. The commitment of these volunteers to continually transform the Center's building speaks volumes about the power of the Irish community in Chicago and the dedication of a group of men and women who have so faithfully stuck together and been committed to volunteering and giving back for three decades.

Indefatigable is perhaps the best word to describe the hard work of volunteer tradesman such at Albon McGill, who climbs up to the roof to check gutters despite Chicago's freezing temperatures.

Dominick McNicholas appears in many of the early photographs of the construction and renovation and can still be found hard at work at the Center to this day.

John Joyce (left) and Ambrose Kelly take a rare moment off and possibly congratulate each other on another job well done.

Frank Neylon, a man of many jobs, helps to keep the work area as tidy as possible.

Volunteers take a lunch break on the roof, enjoying some good weather and probably some good stories, too.

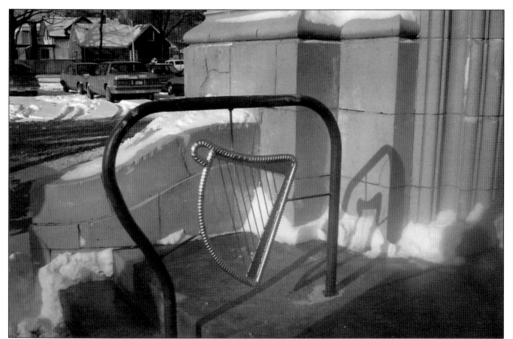

Ironworkers Jim Kilroy and Rich Brenne created the iron harp, located at the north parking lot exit, and later added green shamrocks to their design. Jim and Rich also worked on much of the other ornamental ironwork located throughout the building, along with ironworkers Tom Gardner, Joe Gardner, and Jeff Keating.

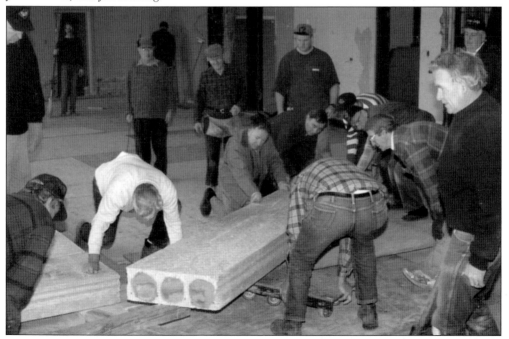

Ambrose Kelly directs the crew working on the new library. A number of former classrooms had to be opened up to make room for the library's children's area, adult reading room, and circulating library shelves.

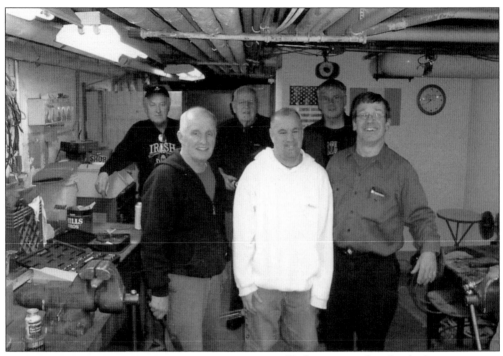

Gathering supplies for the basement are, from left to right, (first row) Bob Blackwell, Paul Heneghan, and Tom Wolis; (second row) Phil O'Connor, Clay Haston, and Chuck ? .

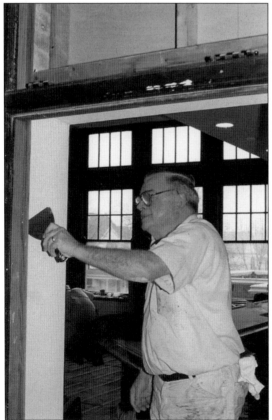

Bill Casey is shown putting his skills to good use.

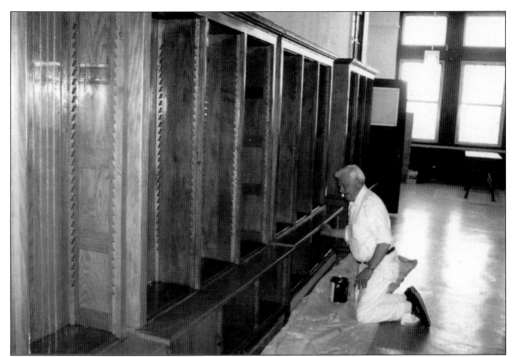

Mike Kilcoyne meticulously stains the floor-to-ceiling bookshelves that line the second floor, displaying library books, museum offerings, and a rich smattering of Irish treasures. The shelves originally were housed in the classrooms and covered in paint but were spruced up to showcase the heirlooms says librarian Peig Reid.

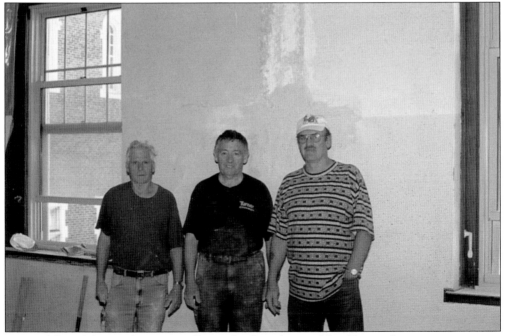

Pictured from left to right, Ben Griffin, Mike Geraghty, and Jim Flynn take a moment to pose for posterity.

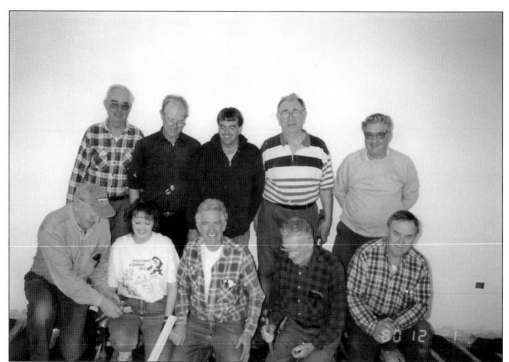

In this photograph are, from left to right, (first row) Henry ? , Peggy Murphy, Ambrose Kelly, Frank Neylon, and Martin McGuane; (second row) Albon McGill, Coleman Travers, Sean Burke, Pat Henneghan, and Dominick McNicholas.

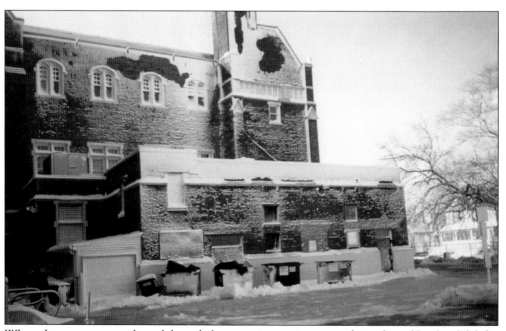

When the temperatures dipped down below zero, it was time to work inside and be thankful the boiler was working.

There was always time for a good and hearty hot lunch. On the left in the foreground is Frank Neylon, followed by Brendan Cashin (son of founding members John and Nora); sitting across from Frank is Pat Heneghan, whose son Paul began volunteering with him at an early age.

Sean Burke and Peggy Murphy get ready to do some gardening. Peggy's association with the Center began when she was the first woman to join the indoor-outdoor construction crew.

A large group of volunteers and supporters gathers together to celebrate the hard work and the community that has been formed at the IAHC.

Joe Reid and a young assistant lay down the boards in the Fifth Province. The wood was donated to Tom Looney by a friend at Piper's Alley, an Old Town Chicago tourist attraction.

Doing some landscaping work in front of the Center are, from left to right, Sean Burke, Dan Connell, Charlie Fitzgerald, and Frank Neylon.

Four

THE HISTORY
OF SPECIAL EVENTS

"St. Patrick's Day was a national holiday in our house," says Mike Shevlin, son of one of the IAHC's first founding fathers and first president Mike Shevlin. "I was the only kid in my school (Our Lady of the Wayside in Arlington Heights) that got to miss school every year to go to the parade." The annual IAHC St. Patrick's Day celebrations and the annual summer Irish Fest have been paramount holidays since the days when the Center was just a dream in the hearts of its founders. "There is nothing as wonderful as celebrating at the Center," says Therese Kierney of Glenview, who says the annual events are musts on her family's calendar.

Today, the IAHC continues its tradition of hosting some of Chicago's biggest St. Patrick's Day celebrations. In 2010, more than 10,000 attendees visited the IAHC for St. Patrick's Day celebrations between March 12 and March 20, and more than 15,000 attended Irish Fest in July 2010.

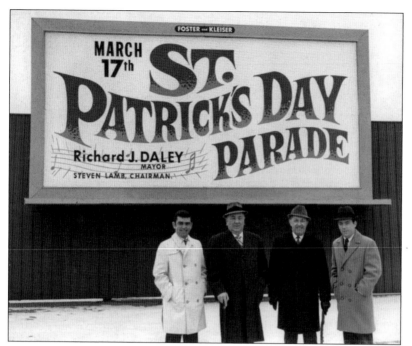

Mayor Richard J. Daley (second from left) assembles with other dignitaries to lead the way in the 1959 parade.

The IAHC has been a part of the Chicago St. Patrick's Day Parade since its beginnings.

Longtime volunteer Brian Donovan made sure that the IAHC sign was securely anchored on the float for the 1994 St. Patrick's Day Parade.

Longtime volunteer Peggy Murphy (left) and a fellow Claddagh Club member are photographed here while decked out in all their parade finery. Peggy has been a tireless contributor to the IAHC, acting in many roles. She has been part of the indoor-outdoor construction crew, managed the Claddagh Club, worked at all the many festivals and celebrations as well as on the tech crew, and managed the Shapeshifters Theater Group.

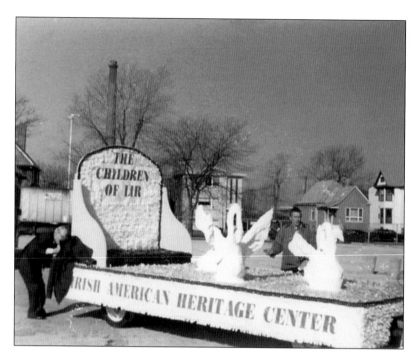

The Center's 1988 St. Patrick's Day float, ready to take its spot in Chicago's annual St. Patrick's Parade, depicts the Irish tale of "The Children of Lir."

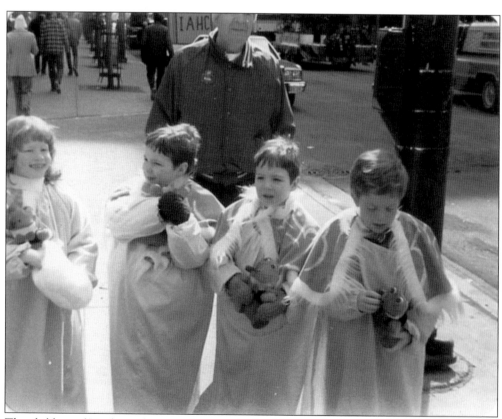

The children of Lir themselves are photographed celebrating St. Patrick's Day.

Paul Heneghan (left) and Tim Gunning and a small friend get ready to represent the IAHC at the parade.

Pictured from left to right, Clay Halston, Peter O'Donnell, Kevin Moran, and Mike Neary put the final touches on the 2005 entry in the parade. Mike Neary, an always-willing and long-time volunteer, travels up to the North Side from the far South Side.

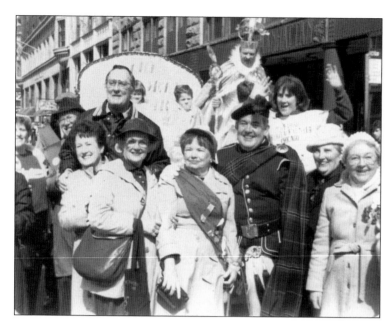

Former Illinois governor James Thompson (black coat with striped collar) joins the IAHC delegation in the 1977 parade.

The annual Irish Fest has been a big hit since its inception, gathering revelers young and old. The celebration of Irish heritage comes to life at the many social events held at the Center throughout the year, with green hats, carnations, and shamrocks. More significantly, members, friends, and longtime volunteers come to the IAHC to celebrate the power that comes from the shared pasts of the family members who came before.

Maureen and Pat McKenna, photographed with Danny Dignam (right), are enjoying a day at the annual Irish Fest, which is the marquee weekend for the IAHC.

Writer and publicist Ann Serb and her husband enjoy a day at the 2002 Irish Fest. During the festival, visitors find numerous attractions and exhibits, both inside and outside. The festival is held annually and attracts about 15,000 people from throughout the Midwest and across the country.

Mary Keleghan, one of the founding members along with her with husband, Gabe, and an unidentified reveler enjoy a moment at the 2005 St. Patrick's Day party.

Longtime volunteer Paul Heneghan (left) makes sure that no one at the Fest goes thirsty.

Despite all the months of hard work that go into pulling off Irish Fest, the staff shows that a good time is had by all.

Fest attendees hop in the elevator to head upstairs and see what activities are happening there.

Jimmy Marks is watching over a group of younger Fest attendees in 1997.

A group of singers from Misericordia, home to over 600 children and adults with developmental and physical disabilities, always draws a big crowd with their energetic performance at Irish Fest. The Misericordia Heartbreakers, a performance group comprised of residents from the home, provide musical entertainment every year, making the festival even more of a joyous occasion.

This group of children, now in their teens, enjoys pony rides at the 1999 Irish Fest.

This lovely lass is now probably close enough in age to taste test green beer.

Matt and Brianne Dougherty, decked out in their Irish attire, check out the fireplace in the Fifth Province at the 1992 celebration.

Some of the older dancers are giving the young ones a helping hand at a Fest dance contest.

With faces painted and refreshments in hand, these youngsters are enjoying a concert in the main stage tent at Irish Fest.

Catherine Lally (left) and Jen Hamman greet participants at the IAHC membership table in 1998. Catherine is a longtime member of the Center's cultural committee.

This image shows the huge crowd that turned out to celebrate the 2003 Fest.

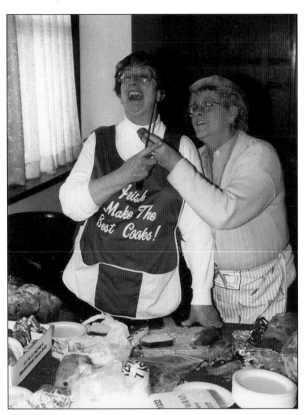

Margaret Burke and Mary Archbold appear to be serenading the crowd at the baked goods table in 2000.

Brian Donovan is the go-to guy at the IAHC for those who want to know more about their ancestry or how to start their search for family information. Brian offers free genealogy sessions the last Sunday of each month from 1:00 to 3:00 p.m. in the library. Here, he answers genealogy questions at the annual St. Patrick's Day celebration.

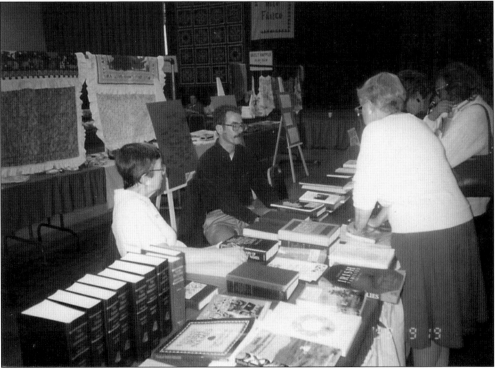

Jerry Gleason, owner of Gleason Chevrolet, holds the winning raffle ticket and the keys to a new Chevrolet at the 2001 Irish Fest. There are almost as many winners of Gleason Chevrolets as there are years of Irish Fests at the IAHC.

Mary Johnson Gorski, current director of the membership committee and chairwoman of the IAHC Green Festival, and an unidentified friend are pictured at Irish Fest.

Bartender Frank Connolly (left) and former operations manager Conor O'Keeffe are taking a moment to enjoy the Fest. Frank serves up the pints that keep the crowds singing "Danny Boy."

Attendees are enjoying their pints and the chance to catch up with each other at the Fest.

Five

DIGNITARIES, STARS, AND OTHER NOTABLE VISITORS

Over the years, the IAHC has rolled out the red carpet for dozens of Irish dignitaries and other famous folk, ranging from the president of Ireland to writers Malachy and Alphie McCourt. The roster of visitors has included a host of celebrities, including Chicago actor Michael Patrick Thornton, who plays Dr. Gabriel Fife on ABC's *Private Practice*, and John Mahoney, known for playing Martin "Marty" Crane, the retired police officer father of Kelsey Grammer's Dr. Frasier Crane on the popular NBC series *Frasier*. Musicians have included internationally acclaimed Irish tenors Ronan Tynan, Frank Patterson, and Tommy Makem as well as Paddy Homan, Gaelic Storm, Liz Carroll, and hundreds of other international and local performers.

On the writing front, bestselling Irish authors have given life to the Center's book club and its annual iBAM! (Irish Books, Arts, and Music) gathering, including Frank Delaney, Malachy McCourt, Peter Quinn, and Mary Pat Kelly.

Many dignitaries have come to the IAHC for ground-breaking activities. Irish president Mary McAleese dedicated the library in 2006. In 1991, Irish president Mary Robinson named the Fifth Province during her visit, saying that the Irish in America, "are the country's Fifth Province." Other politicians have included former Illinois governor George Ryan and then-congressman Rahm Emanuel, Chicago's current mayor.

Many of the dignitaries become "Notable Guests of the Chair." The ranks have included the Irish presidents Mary McAleese and Mary Robinson, Mayor Daley, and Brian Cowan, the current taoiseach of Ireland.

The actual chair is also famous, having been commissioned by the Irish Fellowship Club for the visit of Pres. William Howard Taft when he spoke at their St. Patrick's Day Dinner on March 17, 1910, in the Red Room of the La Salle Hotel. Taft's initials are on an escutcheon at the top of the Presidential Chair. For decades, it was housed at DePaul University, but now it has a home at the IAHC.

In addition to those who have walked through the doors to celebrate the "wearin' o' the green," the Center itself has been hailed as one of the premiere places in the United States to appreciate the formative influences and contributions that Irish Americans have had on US culture and history.

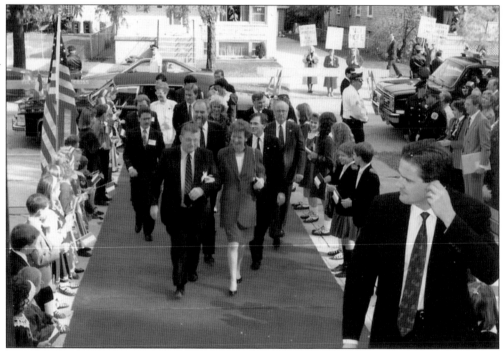

Tom Boyle escorts Irish president Mary Robinson on the red carpet in October 1991 during her visit to the IAHC. Mary was the seventh and first female president of Ireland. She served in this capacity from 1990 to 1997.

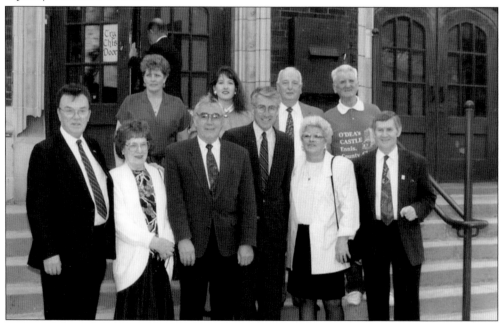

Gov. Jim Edgar visited the Center on May 16, 1993, and took some time to pose on the front steps. Pictured here from left to right are (first row) unidentified, Maureen O'Looney, Jerry Archbold, Gov. Jim Edgar, Mary Archbold, and Tom Looney; (second row) Breege Looney, Brenda Edgar, unidentified, and P.J. O'Dea.

The Presidential Chair, also known as the Irish Fellowship Club's Chair, was housed at DePaul University and was given to the IAHC in 1991. Throughout the years, other notable people who have occupied the Presidential Chair include Pres. Harry Truman and Eamon De Valera, the former Irish president and taoiseach.

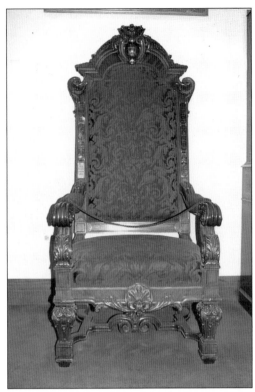

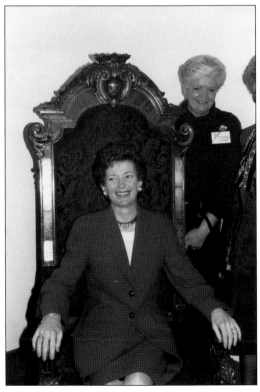

Pres. Mary Robinson sits in the Presidential Chair in the museum at the IAHC during her 1991 visit.

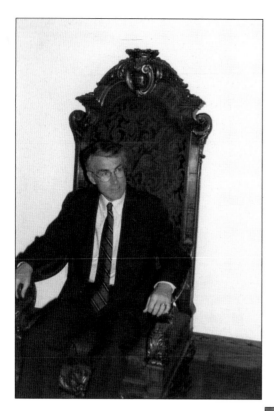

In 1993, Gov. Jim Edgar also took some time to visit the Presidential Chair. Surrounding him in the museum was a square grand piano dating from the late 19th century, an exquisite collection of Irish lace, the first organ from St. Patrick's Church in St. Charles, Illinois, and a series of historic maps showing the Irish contribution to European culture from the 6th to the 12th centuries.

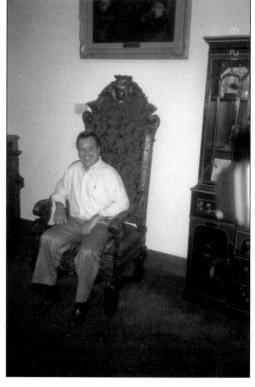

Mayor Richard M. Daley, one of a legacy of Irish politicians in Chicago, is at home at the IAHC in 1997. Here, he takes his post on the Presidential Chair amid the museums magnificent collection of Belleek Parian china and a tapestry by Lily Yeats, sister of W.B. Yeats, to name just several of the standout acquisitions found here.

Irish president Mary McAleese visited the Center in May of 2003. President McAleese is the longest-serving current female head of state.

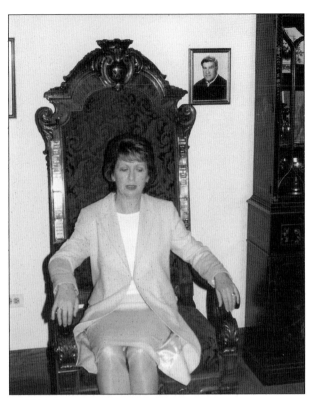

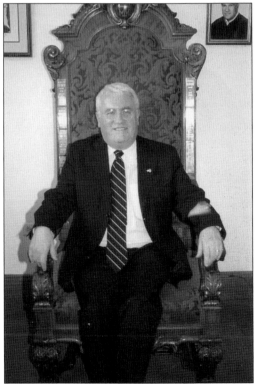

During his visit, Batt O'Keeffe, minister for enterprise, trade, and innovation, enjoyed a moment in the Presidential Chair.

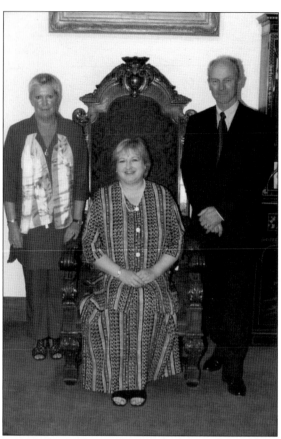

Sile de Valera, minister for arts, heritage, Gaeltacht, and the islands from 1997 to 2002, takes a seat. She is a granddaughter of Eamon De Valera, Fianna Fail founder, taoiseach, and third president of Ireland.

Taoiseach John Bruton is surrounded by, from left to right, Mary Cipolla, Eileen McMahon, Susan Lally, and Bronagh McGill at a dinner at the IAHC in March 1995 celebrating the taoiseach's visit.

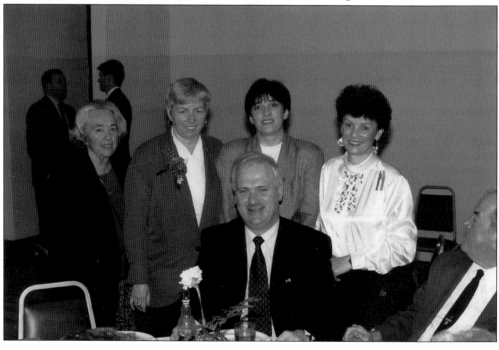

The Healy family was one of the driving fundraising forces behind the opening of the Center's library.

Authors Edward Burke (standing) and Thomas J. O'Gorman (to the left of Burke) attended a book signing in the Fifth Province for their book *End of Watch* in June 2007.

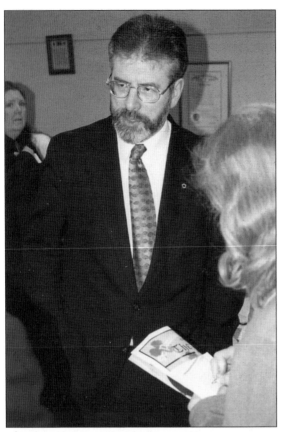

Gerry Adams, president of Sinn Fein, one of the largest political parties in Northern Ireland, visits the IAHC library.

Bob McNamara visits with Illinois congressman Rahm Emanuel at Irish Fest in 2003, years before the future White House chief of staff and threw his name in the ring as a Chicago mayoral candidate in 2010.

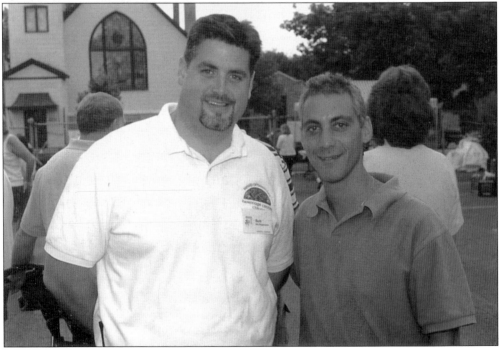

From left to right, Tommy Makem, former IAHC president Chuck Kenny, and an unidentified man are shown at the 2002 Irish Fest. Three of Tommy's sons are members of The Makem and Spain Brothers, who are regulars at the IAHC but also take to the international stage year round, capturing the essence of the Irish genre in folk music.

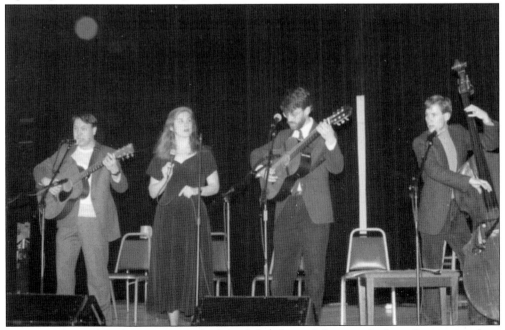

Rising traditional Irish music stars, Irish rock bands, and dozens of talented artists perform regularly at the Center. Here, musician Jamie O'Reilly, a popular ballad singer and recording artist, performs.

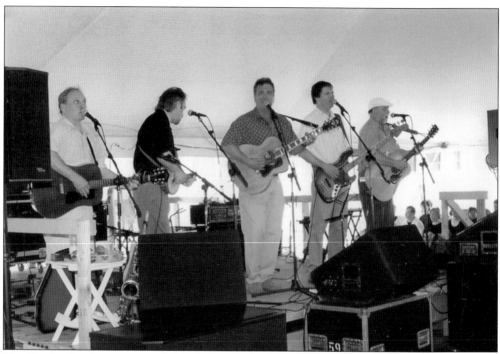

The Dooley Brothers, perennial favorites at the Center, take to the main stage at Irish Fest.

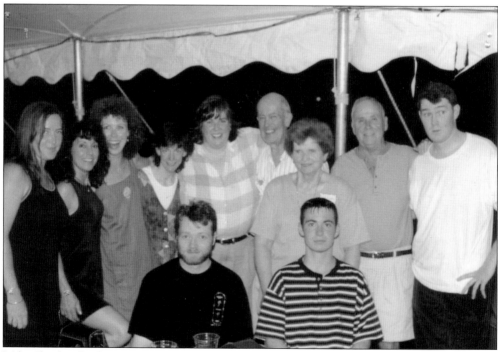

Mike Shevlin (back row, fourth from the right) and his family gather with members of the group Cherish the Ladies.

Six

TAKING A TOUR
OF THE PLACE

Peig Reid remembers the day in 1972 when she was pregnant with her fifth child and waiting at a bus stop at Foster and Leamington Avenues en route to Rogers Park for her job as a librarian for Chicago Public Schools. Suddenly, Hugh and Josie O'Hara, a couple she had recently met through her friend Mary O'Reilly, pulled up to the curb and posed the following question: "Would you be interested in cataloging some Irish books we have in our basement?"

That's how Reid found herself spending many hours in the Forest Glen home of the O'Haras, tagging shelves of Irish books and chatting with Josie and Hugh, who was then the president of the Shamrock American Club, about their dream for a library of Irish books that would be open to Chicago's Irish community who wanted to learn more about and share their common heritage with generations to come. "They had a dream to start a library and build a place where there could be this explosion of knowledge about being Irish," recalls Reid, who today, almost 40 years after those early days in the O'Hara basement, oversees the 35,000 volumes chronicling Irish history and literature at the IAHC.

The IAHC's library opened its doors to the public in January 2006. It includes books, periodicals, newspapers, and audio/visual materials that focus on every aspect of Irish and Irish American life. With clean white walls decorated with the names of Irish authors, the library features shelf upon shelf of books, a special children's center, and a copy of the *Book of Kells* on display. Gaelic-style script illuminates the entrance archway where a long phrase begins, "The world of books is the most remarkable creation of man. Nothing else that he builds ever lasts."

Though the library provided the impetus for their dream, Hugh and Josie O'Hara did not live long enough to see its fruition. "They never lived to see the day, but this was their vision and dream come true," says Tom Boyle. "It is our masterpiece," says Ambrose Kelly about the construction of the library.

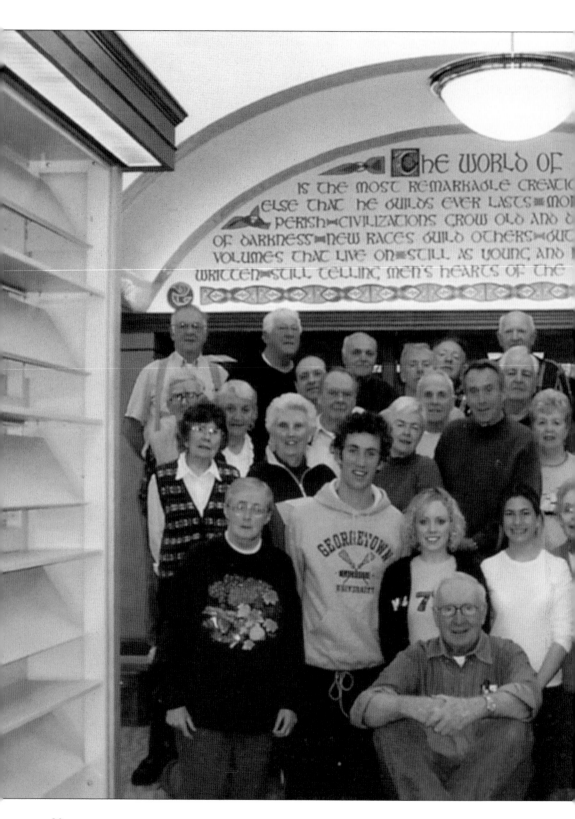

Pictured are some members of the team who joined Josie and Hugh O'Hara's dream to create an Irish library and cultural center in Chicago.

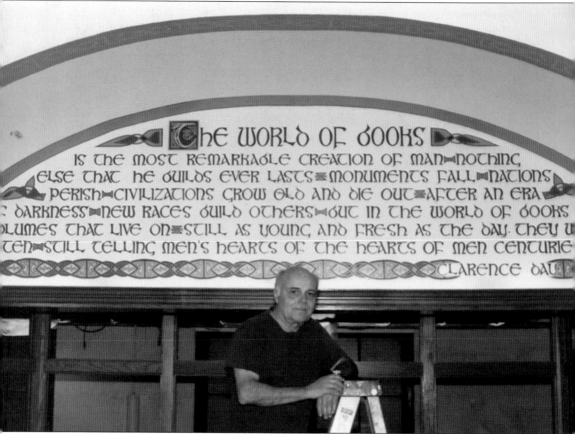

The World of Books is the most remarkable creation of man. Nothing else that he builds ever lasts. Monuments fall, nations perish, civilizations grow old and die out, and after an era of darkness new races build others. But in the world of books are volumes that live on, still as young and fresh as the day they were written, still telling men's hearts of the hearts of men centuries... —Clarence Day

Proud artist Ed Cox enjoys the finished calligraphy design in the library, welcoming all to the world of books.

Photographed at the 2010 iBAM!, Peig Reid is in front of the beautifully restored display cabinets directly across from the library.

The library cake celebrating the opening of the new IAHC library was beautiful to look at and just as good to sample.

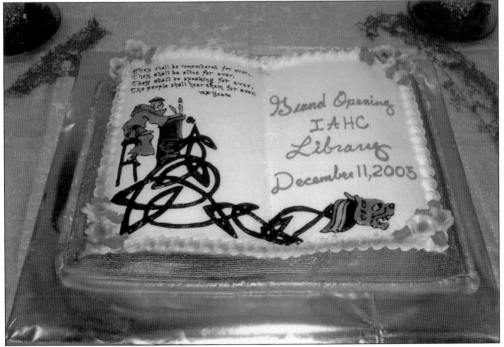

Fr. Jim Kill unpacks some of the Belleek pottery he collected over the years and donated to the IAHC museum.

This vivid display of the magnificent collection of Belleek Parian china is housed in the museum.

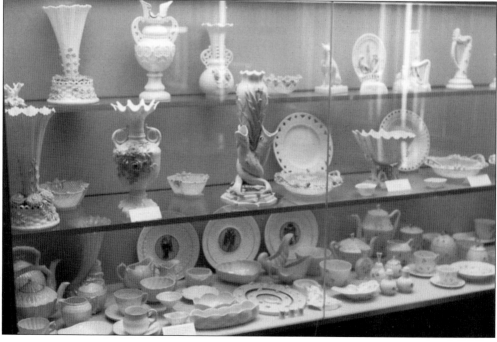

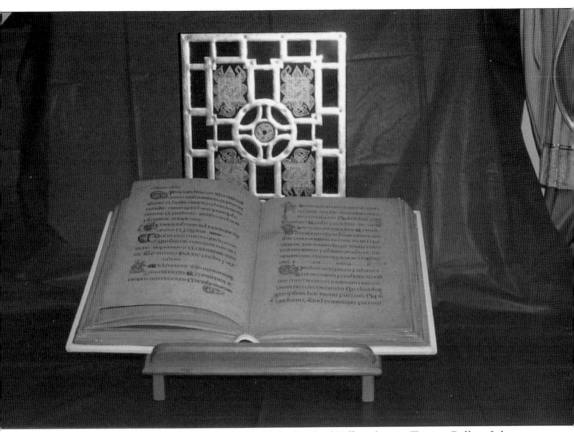

On display in the library is this photograph of the *Book of Kells*, taken at Trinity College Library, Dublin, where it is on permanent display.

Pictured here are, from left to right, volunteer electrician Marty Mersch, consul general of Ireland Gary Ansbro, and artist Ed Cox at the ribbon-cutting ceremony for the opening the IAHC Art Gallery.

Artist Frank Crowley is the director of the IAHC Art Gallery, and his many activities include teaching art, developing curriculum and lesson plans, acting as director of the Children's Center for Cultural Studies, and curating art shows at the gallery. Given his interest in visual art and mythology, he also creates a series of artworks called *Fantasy Celtic Kites*, which were recently exhibited in Takefu, Japan.

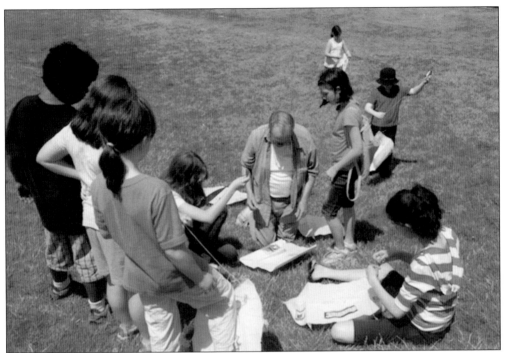

Participants in the Children's Center for Cultural Studies Summer Art Program, directed by artist Frank Crowley, are busy creating art and memories.

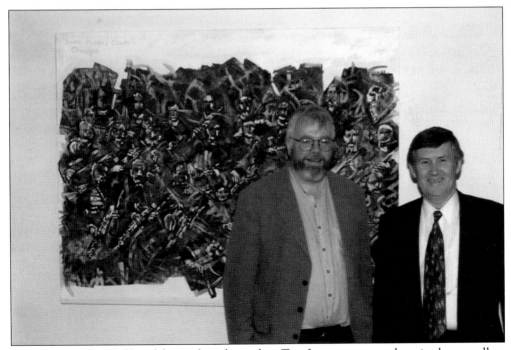

Artist Dara Valley (left) and former board president Tom Looney are seen here in the art gallery at a showing of Dara's work. The show included the painting entitled *Irish Pipers Club, Chicago*, which is based on photographs in Chief Francis O'Neill's *Irish Minstrels and Musicians*.

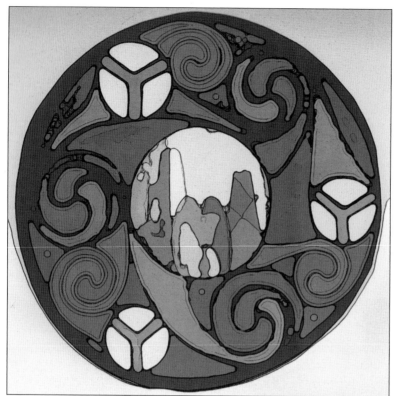

This is titled *Celtic Chicago*, which is an acrylic piece created by Frank Crowley and based on the work found in *The Book of Kells*. Frank teaches Celtic art to both children and adults at the Center.

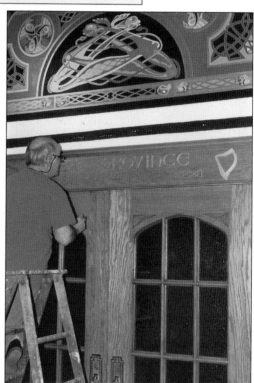

Artist Ed Cox puts the final touches on the entryway to the Fifth Province Pub.

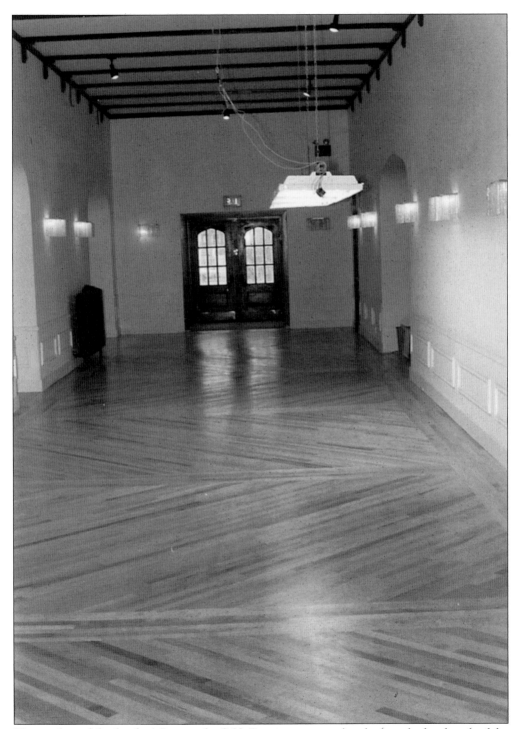

Here, a shot of the finished floor in the Fifth Province gives a close look at the hard work of the tradesman. An enormous amount of work went into pulling out old nails and stripping off paint and stain, resulting in a beautifully crafted floor and a lasting tribute to all those who worked so hard to make it happen.

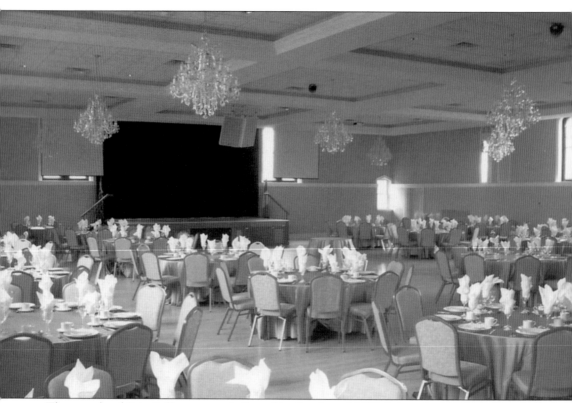

The completed Erin Ballroom was dedicated in October of 2009. It has already been the site of many celebrations and events, including iBAM!, and is often rented out for weddings, banquets, and special occasions.

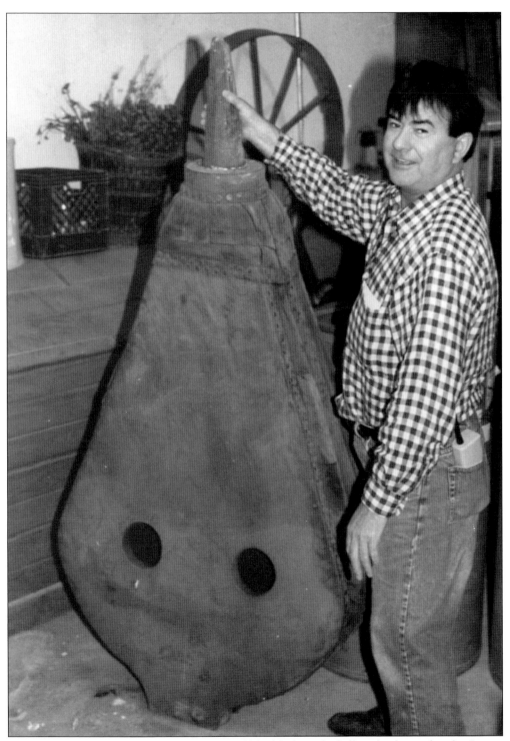

Longtime volunteer Thomas Gibbons shows off the blacksmith's bellows he donated to the Center among other artifacts from Ireland, including a thatcher's needle, a slan (tool for cutting turf), a cobweb brush, an Edwardian kitchen set, a candle box, and a scale.

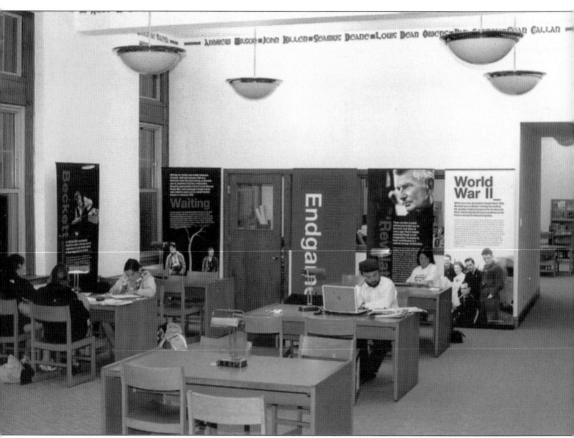

The adult reading room in the second-floor library has hosted such stellar exhibits as the works of Samuel Beckett. Other special collections include an Archival Rare Book Collection that includes a facsimile edition of *The Book of Kells, Lindisfarne, Annals of Ireland,* and the Chief O'Neill musical anthologies.

Volunteer Paul Heneghan is a daily fixture at the Center. He helped prepare and install the two stained-glass windows from St. Mel's that are on display in the art gallery.

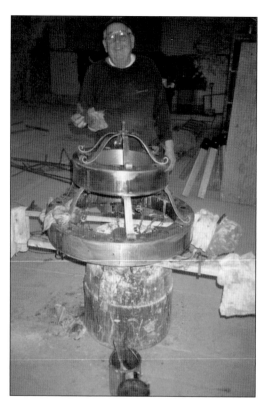

This is what the chandelier that hangs in the front lobby of the IAHC looked like in its original state before workers restored it.

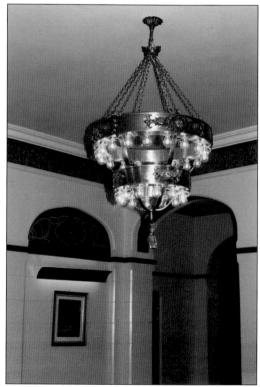

The beautifully restored chandelier now hangs in all its glory.

Seven

CELEBRATING ALL
THINGS IRISH

The Center has become home for many local Irish dance troupes, including the internationally renowned Trinity Academy of Irish Dance, the Mulhern School of Dance, the O'Hare School of Irish Dance, and a premier and nationally ranked Irish Pipe Band. It is also a favored venue and hangout for major literary figures and leading musicians, including the Irish School of Music, the Bua Band, the Elders, Gaelic Storm, The Makem and Spain Brothers, Liz Carroll, and many more. The Center boasts room for dance practice studios and has a myriad of educational programs from literature and language to theatre, film, Gaelic sports, and Irish customs. And of course, the Center would not be complete without The Fifth Province, an authentic Irish pub.

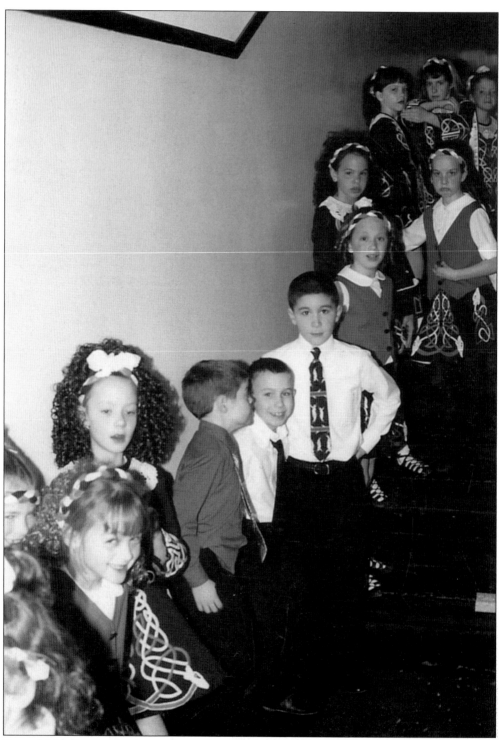

Several Irish dance schools practice and perform at the IAHC, such as the Mulhern School of Dance, the O'Hare School of Irish Dance, the Trinity Academy of Irish Dance, and the Francis O'Neill Club. In this image, dancers are lining the stairway, ready for a performance.

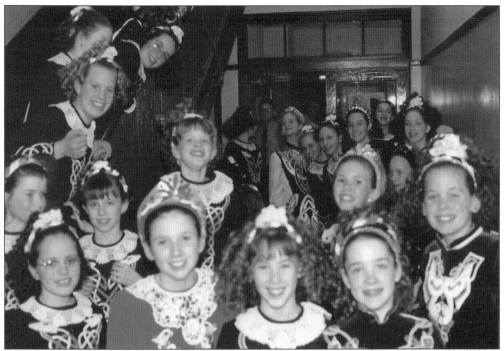

The dancing traditions of Ireland are handed down to future generations at the IAHC in close association with Irish music.

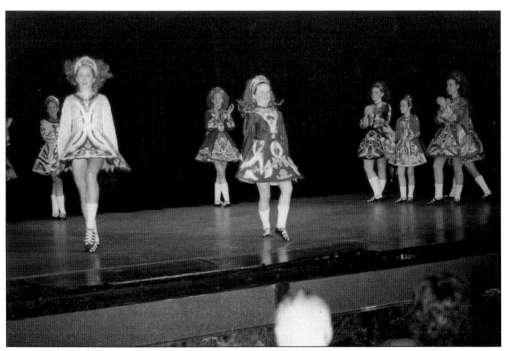

The auditorium fills up when the dancers take to the stage. Here, a group performs for the St. Patrick's Day celebration.

The vision of the founders is realized in the passing down of Irish dance traditions. In this image, another featured group waits to enter, stage left.

The Nimble Thimbles is a group of quilters and artisans who work at all forms of needlecraft. Each year, the group designs and produces a quilt raffled off at the Christmas Bazaar. Rita Adamczyk (standing) and fellow artisans are pictured at the annual quilt raffle table. New members are always welcome, and the group meets on Tuesday mornings and Wednesday evenings in room 205.

Mary Garrity is very proud of the display of beautiful work created by the artisans of the Nimble Thimbles at the annual Christmas Bazaar, which follows Mass and breakfast and starts off the holiday season.

Costumed participants at an early St. Patrick's Day celebration include, from left to right, Gail Brunton, Joe Flaherty, Ann Carney, Frank Kilker, Brian Donovan, Karen Crotty, and John O'Malley.

Always on hand are the volunteers who slave away in the kitchen for St. Patrick's Day. Breege Looney remembers that they named it Bridget's Kitchen because she and a group of other volunteers used to serve pizza from that kitchen on the nights when the dance schools came for lessons in some of the classrooms.

John O'Grady (center, back to the camera) leads a céilí dancing class. Members of the Francis O'Neill Club dance, teach, and hand down the tradition of the folk dances of Ireland. A Céilí Mor (Big Céilí) is held the first Friday of each month.

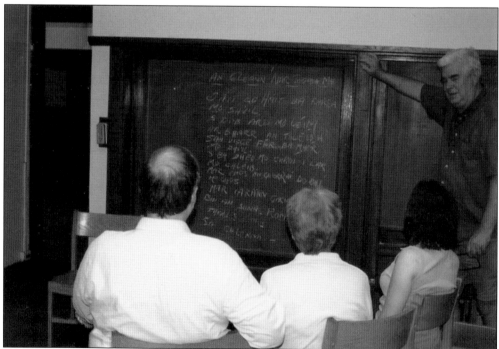

John O'Grady is making sure that the Irish language is remembered.

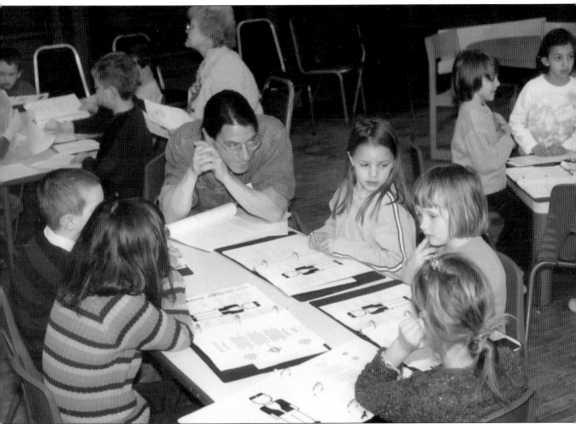

Brian Doyle taught children the language at the Irish School on Saturdays. Here, the late Michael McMechan, who taught the adult language classes, gives a lesson to some children, making sure that the language lives on.

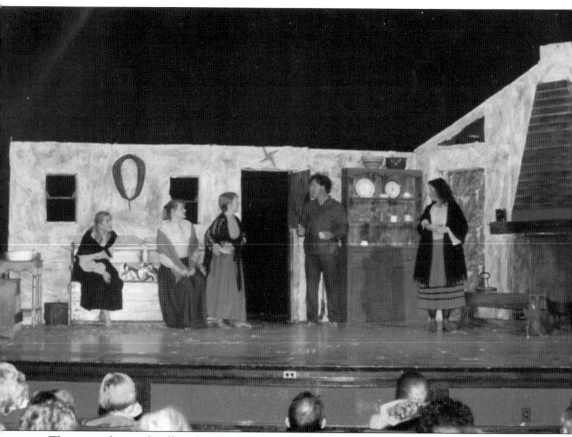

Theater is alive and well at the IAHC, where there is now a small theater on the third floor in addition to the 650-seat auditorium. Here, members of the Shapeshifters perform *Playboy of the Western World* in Mary O'Reilly's legacy, the auditorium.

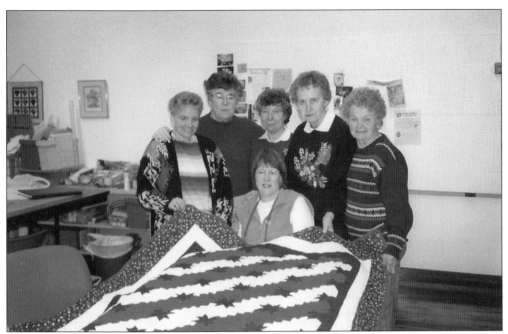

Nimble Thimble artisans show off the beautiful raffle quilt at the 2002 St. Patrick's Day party. Members are, from left to right, (standing) unidentified, Nora Cashin (one of the founding members along with her husband, John), Ruth ? , Audrey Murphy, and Mary Garrity; (seated) Nancy Liston.

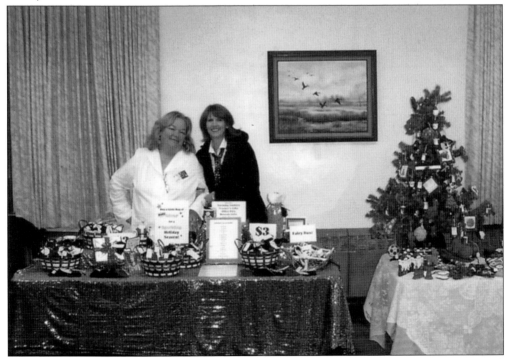

Smiling for the camera, JoAnne Loper (left) and Kathy Kane had a great time hosting their craft table at the Christmas Bazaar.

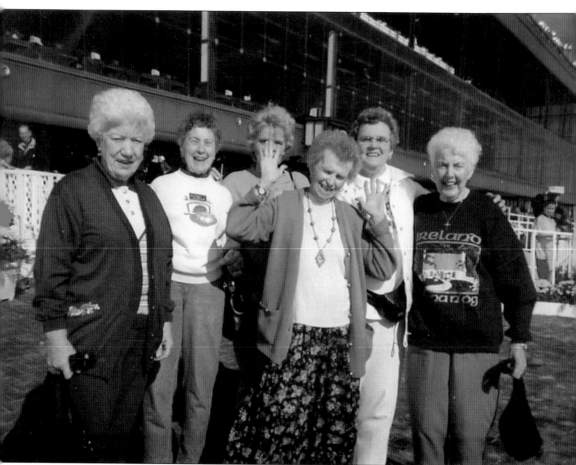

Members of the Tir Na N'Og, a senior activity and social group, enjoy a day at Hawthorne Race Track. The group meets the first Wednesday of every month at 11:00 a.m.

The Easter Bunny often visits the IAHC and has found a friend at the annual Palm Sunday breakfast after Mass in 1995.

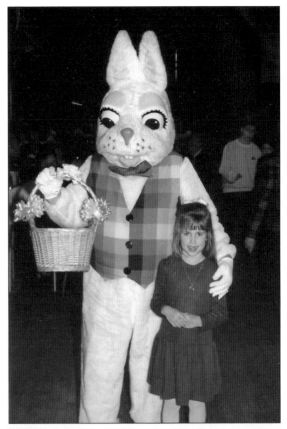

Santa visits the Center each year after the Christmas Mass and breakfast. Here, some hopeful children line up to chat with Santa in 1993.

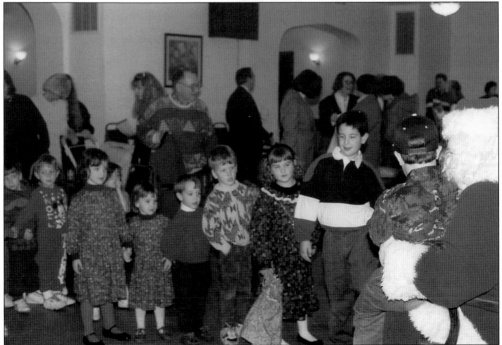

Tom Boyle (far left) and his golfing buddies are seen enjoying the annual golf outing.

Catherine Lally (front right) and some of her friends also enjoyed the golf outing.

Longtime volunteer (daughter of founding members John and Nora Cashin) Maureen Cashin Bolog joins her family at the Christmas breakfast in 2007. At the table are, clockwise from the left, Emmett Kegler, Mary Bridget Bolog, Keith Bolog, Jack Bolog, Maureen Bolog, Sharon Kegler, and Theresa Bolog. Maureen is the founding director of the Irish School, the Irish Arts Club, and the Irish Teen Theater. Maureen is currently an acting coach and operates Actor's Craft in Kenosha, Wisconsin.

Former members of the Teen Theater Workshop pose in front of the IAHC. They were trying out ideas for a poster to advertise the show they were creating.

In addition to language, culture, and art, the Irish school also offered traditional craft and baking lessons. Here some budding bakers are getting the hang of it.

Ed Cox has shared his artistic skills and his experience as an elementary art teacher and has a rapt audience of attendees at an Irish school class in 2001.

The Irish school continues under the direction of Frank Crowley. Here, some young artists learn and work in the art gallery.

The Center is often the site of parties and events. From left to right, Nora Murphy, Bart McCaffrey, and Maureen O'Looney celebrate Bart's 82nd birthday.

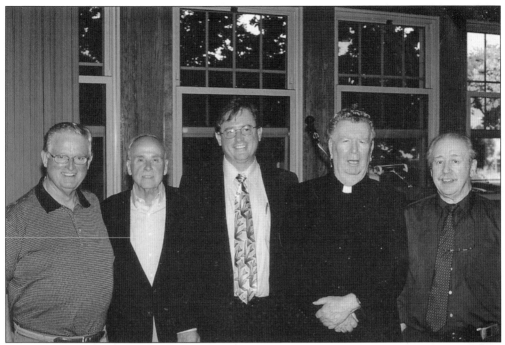

Attending a goodbye party in the Fifth Province are, from left to right, Tom Boyle, Chuck Kinney, Pat Bloom, Fr. Kevin Shanley, and Noel Rice.

Members Mary and Jim Garrity enjoy a celebration with Pat Flaherty (right).

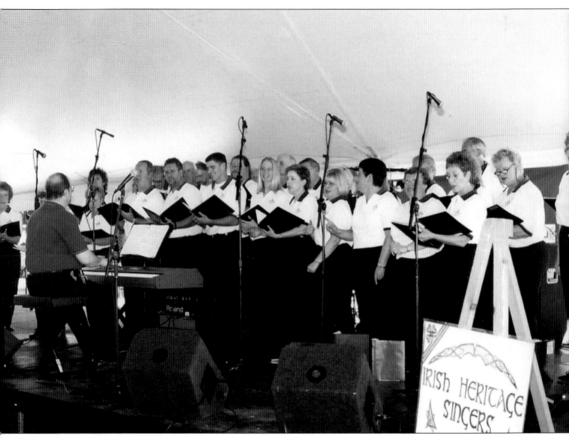

The Irish Heritage Singers always perform at Irish Fest. The group was founded by Mary O'Reilly, and they are sponsored by the Center. They perform at both the Christmas and Palm Sunday Masses, the St. Patrick's Day party, and Irish Fest in addition to many other performances given throughout the city.

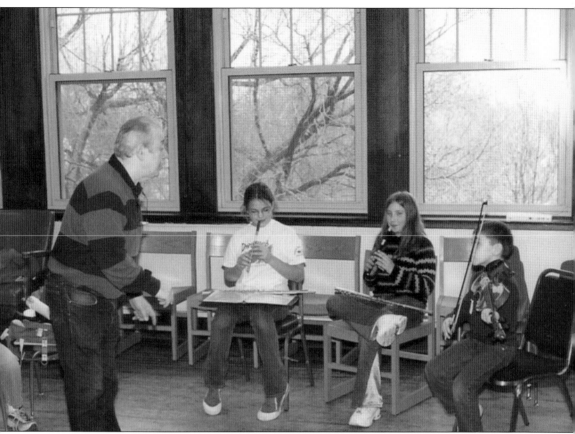

Noel Rice teaches his Academy of Irish Musicians. Noel has been a major influence on the cultural vision of the Center. He remembers talking long into the night with Hughie O'Hara about what they hoped it would become. From County Tipperary, Noel learned music from his dad. He served as president of the board from 2006 to 2008. His three-part mission has been to teach kids (as a member of the cultural committee it was his idea to begin Irish School), run céilí dances, and bring concerts to the Center. Noel also performs with his band, Baal Tinne.

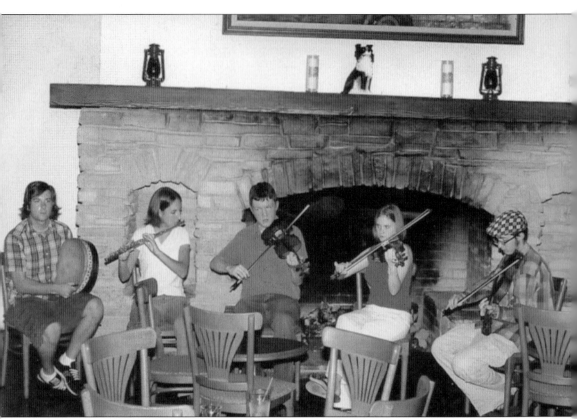

The Academy of Irish musicians performs in front of the fireplace in the Fifth Province. Included in this image are, from left to right, Brian Wade, Katie Jonaitis, Brendan Byrne, Maggie Cusik, and Alex Biardo.

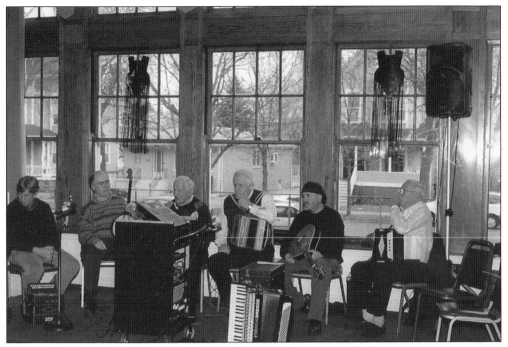

In 2002, session musicians play for a new member's party in the Fifth Province.

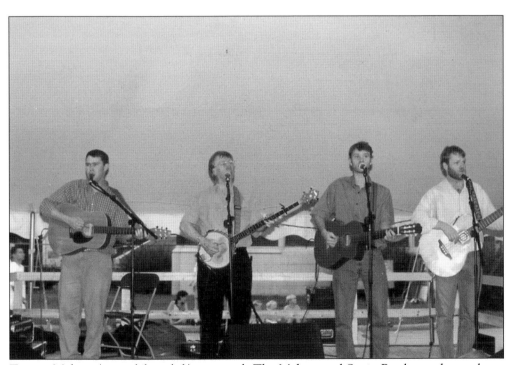

Tommy Makem (second from left) sings with The Makem and Spain Brothers, who are long-standing favorites at the Center.

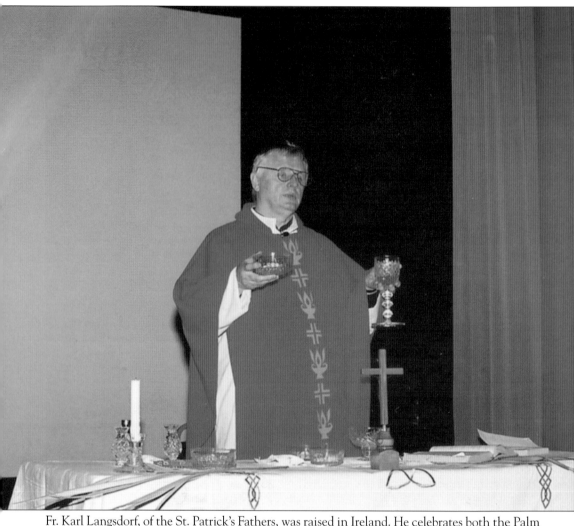

Fr. Karl Langsdorf, of the St. Patrick's Fathers, was raised in Ireland. He celebrates both the Palm Sunday Mass and the Christmas and Advent Mass each year in the auditorium.

Eight

LOOKING AHEAD

As the world becomes increasingly mobile, and international genealogical research becomes one of the fastest-growing pastimes, the IAHC is uniquely positioned to be a premiere resource as a venue and community for shared Irish heritage in Chicago and across the country.

There is a buzz about the place as the organization is both celebrating its past and reinventing itself for future generations. As a testimony to that effect, the nonprofit organization's membership has jumped by almost 1,000 members to 2,140 members in 2010.

Future plans are expansive and impressive. A Famine Museum is just one of the programs targeted at carrying on the Irish heritage. There is also an Irish American Hall of Fame. The Hall of Fame attempts to preserve the story and history of individuals who through leadership, work, and vision contributed to the success of the Irish in America, the preservation of Irish culture in America and in Ireland, and the continued strengthening of the bond between the two countries.

The Center continues to expand its outreach to bring together and work closely with other Irish organizations throughout Chicago. "The goal is to push forward the mission while creating a sense of home and to be a gathering place for the entire Irish community in Chicago," says president Bob McNamara.

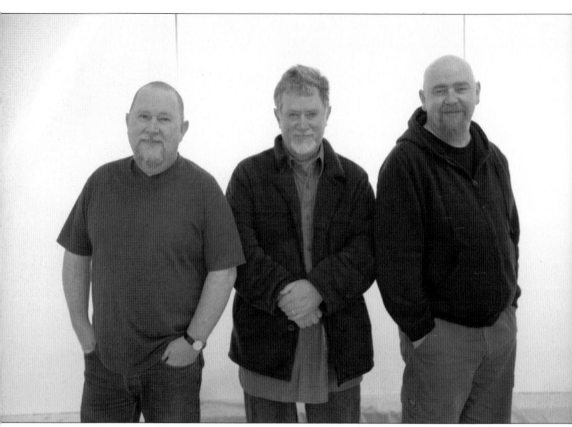

The Bogside Artists, a trio of mural painters from Derry, Northern Ireland, were part of the more than 100 Irish authors, artists, and musicians under one roof at the iBAM! Chicago 2010 event. The celebration featured book signings, panel discussions, workshops, art exhibits, theater performances, live music, and kids' activities. (Courtesy Cathy Curry, 4GirlsPhotography.)

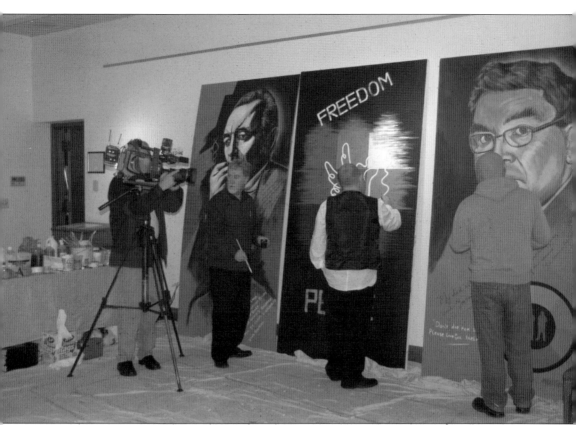

These three murals were created by the Bogside Artists during the iBAM! event. The painting on the far right celebrates John Hume, the Nobel Peace Prize winner honored at iBAM! as Person of the Year for his dedication to the peace process in Northern Ireland. (Courtesy Cathy Curry, 4GirlsPhotography.)

Cliff Carlson (left), publisher of the *Irish American News*, and Tom Boyle, columnist for the publication, smile for the camera at iBAM! 2009.

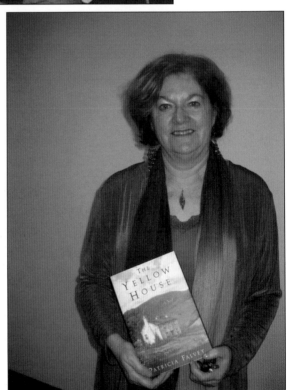

Author Patricia Falvey signed copies of her book, *The Yellow House*, at iBAM 2010.

Sandra McCone, author of *Magical Tea Party*, embodied one of her favorite faerie characters at the 2010 iBAM! and hosted a wonderful and magical tea party in the children's room of the library, where she shared the tales and legends of old Ireland.

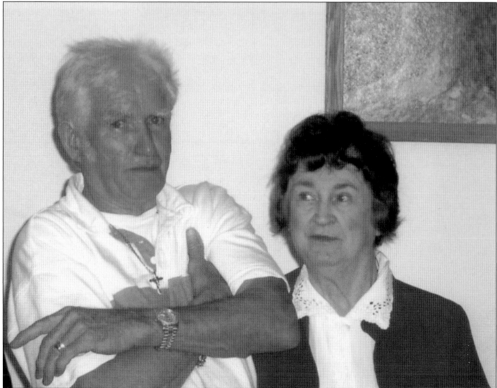

"In the door feet first on an April day in 1985" and always ready for a new project is Ambrose Kelly, who is seen here with his wife, Theresa.

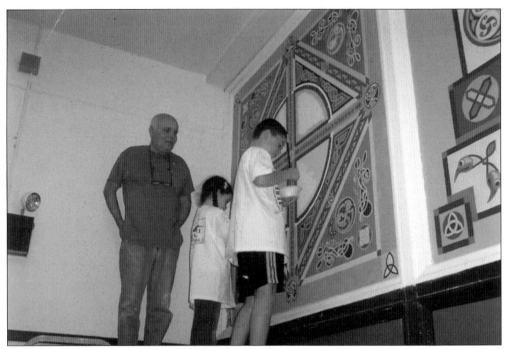

Ed Cox passes the torch to his grandchildren Frank and Maura Lally.

The vision of the Irish American Singers is to preserve, perform, and bring to life the cultural heritage of Irish music. To date, the group is one of the very few Irish American choral ensembles in the United States.

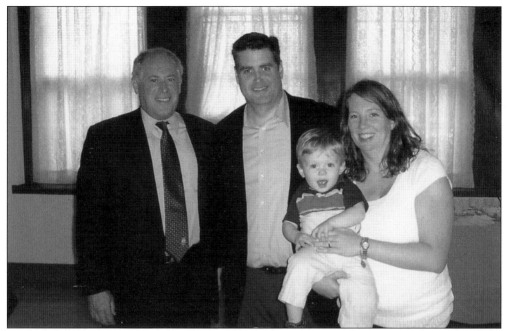

Chicago Irishmen, some famous, some just ordinary people celebrating their Irishness in extraordinary ways, are drawn to the myriad events and celebrations at the Center. Here, Illinois governor Pat Quinn (left) enjoys Irish Fest with board president Bob McNamara and his wife, Jeannie, eldest of three children, and their son T.J.

Chuck Grant (left), executive director Tim McDonnell (right), and his dad, Jim McDonnell, enjoy some beautiful weather at Irish Fest 2010. McDonnell's parents were born in Ireland and live on the East Coast but are regulars at many events.

Here, volunteer Jim Kinney (left) and board member Frank Gleeson take some time to chat during Irish Fest 2010.

Kathy O'Neill serves as the social networking guru and public relations point person, spreading the good news about the Center throughout the Chicago area and across the Internet.

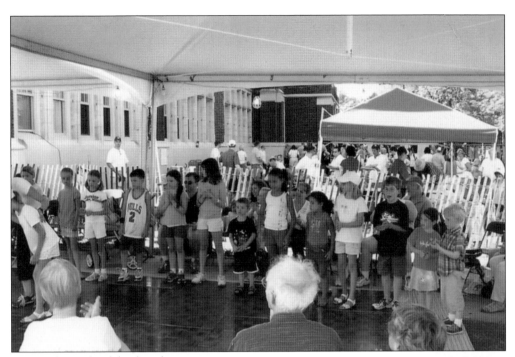

One of the goals of the founders was to pass down the Irish culture and traditions to the next generation. Here, the faces of the future serve as testimony to a dream achieved that will continue to live on for years and years.

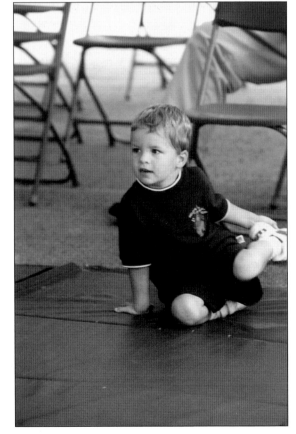

For younger generations, Irish grandparents sometimes are just faded black-and-white photographs. The memories, lives, talents, hopes, and dreams of the O'Haras and Shevlins and all who dreamed of a home for the Irish in Chicago will live on through new members and friends such as this boy.

www.arcadiapublishing.com

Discover books about the town where you grew up, the cities where your friends and families live, the town where your parents met, or even that retirement spot you've been dreaming about. Our Web site provides history lovers with exclusive deals, advanced notification about new titles, e-mail alerts of author events, and much more.

MADE IN THE

Arcadia Publishing, the leading local history publisher in the United States, is committed to making history accessible and meaningful through publishing books that celebrate and preserve the heritage of America's people and places. Consistent with our mission to preserve history on a local level, this book was printed in South Carolina on American-made paper and manufactured entirely in the United States.

This book carries the accredited Forest Stewardship Council (FSC) label and is printed on 100 percent FSC-certified paper. Products carrying the FSC label are independently certified to assure consumers that they come from forests that are managed to meet the social, economic, and ecological needs of present and future generations.

FSC

Mixed Sources
Product group from well-managed forests and other controlled sources

Cert no. SW-COC-001530
www.fsc.org
© 1996 Forest Stewardship Council

Find Your Place in History.